MODERN EGYPTIAN ART
The Emergence of a National Style

MODERN EGYPTIAN ART

The Emergence of a National Style

Liliane Karnouk

with a Foreword by
P. J. Vatikiotis

The American University in Cairo Press

Dar el Kutub No. 7051/87
ISBN 977 424 176 2

Printed in Egypt at Nubar Printing House

Contents

List of Illustrations

Text references to illustrations are marked §

vii

First Colour Section

Second Colour Section

Acknowledgements

Researching into modern art in Cairo sometimes feels like trying to cross the legendary Labyrinth. Nevertheless, by following the Egyptian proverb "He who asks does not get lost", we all eventually get closer to where we want to be. We also make many new friends. I would like to thank all the people who helped me to accomplish this portion of my work, especially Dr. Naim Atiya, Mr. Sobhi al-Sharuni, Dr. Mustafa al-Razzaz, Mrs. Gloria Karnouk, Ms. Hanaa Abd al-Alim, Mr. Kirk Tougas, Mr. Brian Shein, and finally Mr. John Gerhart and the Ford Foundation for the partial financial support which enabled me to complete this book.

Foreword

by P.J. Vatikiotis

"Unlike the situation in Western Europe, where modernism sprang out of rapid technological development, modernism in Egypt was embraced as a symbolic inducement to cultural and political change". It is in the context of these two different situations that Liliane Karnouk attempts the first survey in English of modern Egyptian art. Indeed, hers is a bold and imaginative undertaking since modern art in Egypt developed as an integral part of the country's national revival and its long-standing contacts with Europe, in fact, its political subordination to Europe for nearly a century. However, a country with over five thousand years of history and uninterrupted geographical, ethnic and social continuity could hardly receive the European imprint in any placid or straightforward manner.

Needless to say, the modern state founded and nurtured by the Muhammed Ali dynasty in Egypt provided much of the impetus and momentum for the interaction between European culture and local or native cultural forms, between modernity, however defined, and tradition. This has been no less true for art, literature and culture than it has been for state administration, education, military organization, trade, commerce and industry.

Egypt's artistic past survived in the Pharaonic monuments unearthed by archaeologists. Then the great strides made by Egyptologists early in the nineteenth century unlocked many of the buried secrets of ancient Egypt. Added to this legacy was Coptic religious art of the Christian era, followed by the splendours of Islamic Cairo after the tenth century AD.

It was, however, not only the work of European archaeologists and scholars that awakened Egyptians to the glories of their past. The patronage of the ruling house and the sensitivity of the first modern elite of educated Egyptians to these discoveries, as well as to their newly-acquired knowledge of European culture, were equally important stimuli to the development of modern Egyptian art. Furthermore, the unbroken tradition of a people and society within the same territorial boundaries produced the cumulative rich treasure of folk and ethnic arts and crafts on which the modern artist could also build.

Although the modern Egyptian artist may have had a ready home-grown base and tradition from which to work, he was none the less faced with certain dilemmas which he had to resolve if his work was to have both local-national and a wider international meaning or message.

This first volume of a projected two-volume study discusses these dilemmas while offering an interpretative survey of the first three generations of modern Egyptian artists from 1900 to 1956. It considers the earliest dilemma they faced this century: whether to emulate European forms and norms blindly, and thus lose all connection with their native tradition, or to revive traditional and ethnic folk art and risk marginality at best, and at worst oblivion, in the world of international art. Egyptian artists also faced the vexing problem—sometimes a crippling difficulty—of observing two rather different and disparate value systems, one the native Egyptian and the other the Arabo-Islamic. In her first volume the author skilfully records their search for a

balance between "loyalty to an imposing past, and their effort to liberate [themselves] from its burden", a dialectic which she presents as the key to the development of modern Egyptian art.

In discussing individual artists, such as Mukhtar, Said, Naji, Ayyad, Jazzar and Nada, Liliane Karnouk encompasses in her study the nationalist, anti-traditional internationalist, folk realist and visual symbolic artistic expression in modern Egypt. By devoting the last chapter of her study to the brilliant—and singular—Egyptian architect, Hasan Fathi, she has provided the transition from modern Egyptian art inspired by the glories of the country's past and its national awakening to that inspired by the artist's response to and expression of change and the contemporary problems of his human-physical environment.

Modern Egyptian Art may well become an essential source for the study of the modern history of Egypt.

P.J. Vatikiotis
London, June 1986

INTRODUCTION

Egypt is a land of polarities: a fertile black valley juxtaposed to arid sands, a temperate Mediterranean coast that dissolves into the African continent. It is an agricultural oasis that sheltered a traditional way of life for thousands of years, and an intercontinental crossroads open to every external cultural and political influence. Further, it is both a country included in the transnational Islamic *ummah* and a nation with its own distinctive character formed by a long history of successive civilization: Pharaonic, Coptic, Arab and European. For the modern Egyptian artist, the polarities and paradoxes multiply.

Modern Egyptian artists share many concerns with artists from other previously colonized third world nations that have recently achieved national independence. In such countries, art always involves a search for renewed identity and national consciousness; it serves as an indicator of social and political change. It was not by accident that, in the Egypt of the 1920s, the modern art movement and the nationalist movement coincided. In Egypt, modern artistic expression has both emerged from nationalism and given that nationalism tangible form in much the same way that, in other contexts, Gothic architecture debated mediaeval Christian theology or classical Greek theatre debated philosophy.

Soon after Napoleon's expedition to Egypt in 1798, the concepts of both European aesthetics and of a world of nation-states were planted in the Egyptian urban intellectual milieu. It took more than one hundred years for Egyptians to adapt these notions to fit their own interests. In the development of modern art and nationalism, both artists and politicians responded to the change of identity produced when the idea of belonging to an autonomous *ethnicity* (be it Coptic or Islamic and so on) evolved into that of *nationality*: a unified Egyptian nation.

Ethnic arts embody a collective folk tradition rooted in the rituals and cultural history of the community. These ethnic arts flourished, quite independently of each other, within the Islamic *ummah*—the mosaic of races, cultures and nationalities which form the community of Islam. By contrast, the concept of art as it evolved in Europe over the past centuries was firmly rooted in the modern concept of nationhood and regimented by the same rules (unification and centralization within its borders, autonomy and differentiation from other nations). Further, the aesthetics of European art assume that, regardless of its specific national origins, the visual language of high art (a fundamentally urban, elitist language) is universal, and that great artists from all nations compete for the mastery and control of its vocabulary. Thus, ethnic and modern oppose each other: the former is regional and (at least in Egypt's case within the *ummah*) transnational, while the latter is centralized and international.

From rural and communal roots, a modern nation such as Egypt could not have developed without a deep and complex cultural revolution. The Egyptian artist has

had to resolve a double dilemma. The first is whether or not to become an artist in the European individualistic sense and thus risk losing a connection to the native soil and its traditions, or whether to revive the traditional ethnic arts and risk remaining marginal to the world of international high art. The second dilemma is the need to articulate the existence of several value-systems historically coexisting within this nation on two levels: the Islamic and the Egyptian.

In Egypt, modernism expressed itself in artists' efforts to transform an Egypto-Islamic style into the new "universal" visual language of international art, while at the same time expressing the new self-image of Egyptian political reform. Modernism, which began with the wearing of the first imported tie, rapidly expanded to affect the applied arts. In the fine arts, however, it had a relatively slow start: like music, art cannot be explained by simply translating it into the native language. It must be simultaneously experienced and understood. Art had to be introduced through instruction and that could only be provided by western artists. In his book *La Peinture Egyptienne,* Aimé Azar observes that, with rare exceptions, the first two generations of artists up to the mid-1930s produced samples of a sub-product, and that the School of Fine Arts provided instruction based on clichés without foundation and limited itself to the teaching of canonical rules. However, he adds that the apprenticeship had to be undergone and that failures were inevitable so that the next generation would successfully master this imported art.[1]

Unlike the situation in western Europe, where modernism sprang out of rapid technological development, modernism in Egypt was embraced as a symbolic inducement to cultural and political change. Its successes have occurred as Egyptian artists break through the ambivalences, polarities and paradoxes of their situation and, by mastering formal means of expression, develop greater individual freedom and confidence in responding to the historic moment. Although highly personal and unique to each artist, this achievement is well-illustrated in a recent statement by the painter Sarwat al-Bahr:

> No need to say that I am not the only one to experience those feelings which I try so clumsily to express. I can only claim to add my personal contribution as an artist who is feeling his way in a universe of three dimensions: the Pharaonic, the Arab and the Universal, and who breathes air through those three lungs. At first, I tried in vain to synchronize their rhythms. Then I realized that each of them has their own way of gasping, laughing, sobbing...I decided then to breathe according to my own nature, to express myself in the rhythm of my breath at that very moment, more than happy if that breath carried me into the past or the future and allowed me to capture the moment, loaded with past, loaded with future.[2]

The search for a balance between loyalty to an imposing past and the effort to liberate oneself from its burden is the key to modern Egyptian art.

ONE

Egyptian Awakening

National identity is essentially the character developed by people affected by common environmental and historical situations over the course of centuries. In Egypt, the chief environmental factor is, of course, the Nile. In an overwhelmingly agrarian society, the flooding of the Nile conditioned the activities of the people and unified them through their dependence on its capricious behaviour. The great river has also been the main medium of communication, running through the land like a spine and affecting every part of its extended body. Foreign penetration of the Nile waters has usually meant the conquest of almost all of Egypt's habitable land.

The chief historical factor in Egyptian identity is the fact that for almost twenty-four hundred years, beginning with the Persians in 525 B.C., Egypt was uninterruptedly under occupation: a country without being a nation, a land where civilizations flourished and influenced other nations while the Egyptian people remained under the power of a succession of foreign invaders. P. J. Vatikiotis has defined this historical factor as a consistent and characteristic attitude of Egyptian unity in suffering through foreign oppression, demonstrated by conservatism in arts and crafts and by a clinging to the traditions and beliefs of their society.[3] Savary, in 1778, described this attitude in one of his letters on Egypt:

> But for ages under the yoke of despotism, they suffered every sort of misery, without lifting up their heads...In spite of their wretched destiny, they passionately love their country and nothing can tear them from it.[4]

Vatikiotis outlines the further development of factors that were to culminate in modern Egypt:

> A series of invasions by foreign conquerors—Hyksos, Persians, Greeks, Romans— has presumably affected this Egyptianity. Three epoch-making events in its history, however, underlie the emergence and development of modern Egypt: the Arab-Islamic conquest in the seventh century, the non-Arab Islamic conquest from the twelfth to the sixteenth century, namely Kurdish, Turkish and Ottoman; and the European encroachment beginning with the Napoleonic expedition to Egypt in 1798. The legacies that these influences have left in the areas of social and cultural change and adjustment constitute perhaps the essential and crucial elements of development.[5]

The changes and adjustments Vatikiotis refers to in this brief chronology resulted from the immense cross-cultural activity which shook traditional Egyptian societies in the late nineteenth century. That cultural activity was marked by the translation of western arts and sciences into Arabic by such outstanding educators as Shaykh Rafii al-Tahtawi and Ali Mubarak Basha, among others. Their work caused a re-evaluation of traditional attitudes, leading to a need for reform and the aspiration to create a new nation.

The First Generation

In 1882, Egypt was once again under foreign occupation, this time by the British military regime. By the turn of the century, 125,000 foreigners had settled in the main cities. Completely autonomous from the Egptian govern- ment, these expatriates led an independent and self-sufficient life under the protection of more than 10,000 British troops. Along with a section of the Egyptian ruling class, they overpowered, both economically and culturally, the mass of Egyptians who were still ninety percent illiterate. The famous Dinshawi incident of 1906 signalled the beginning of a change in the Egyp- tians' humble and submissive attitude: peasant villagers, angered by a group of British soldiers' murderous arrogance, fought back. They were brutally punished but their defiance entered an emerging national mythology of inde- pendence. At the same time, Vatikiotis points out that it is possible to witness in the years between 1906 and 1914 the emergence of exceptional men whose prominence marks an illustrious phase of secular liberalism in the history of Egypt.[6] These men were led by Mustafa Kamil Basha, the founder of the National Party, and constituted an intellectual elite unanimously dedicated to the peaceful achievement of Egyptian independence through education and the massive involvement of the people in progressive action programs.

Prince Yusuf Kamal, a great patron of the arts, was among some others including Ahmad Lutfi al-Sayyid, who took upon themselves the "education of taste." The idea of an art school emerged alongside the project for a uni- versity. At first, the university was opposed by the British and the School of Fine Arts contested by some popular factions who considered it contrary to the country's customs. The art school debate was finally won when Shaykh Muhammad Abduh, the brilliant Azharite scholar, came out in favour of art education and the restoration and preservation of antiquity.

As a religious reformer, Muhammad Abduh believed that in applying Islamic law to modern issues, judgement based on logical arguments rather than fixed law should be applied. Regarding art, he wrote:

As for the Prophet's saying: 'Those who will be most tormented on Judgement Day are image-makers,' it seems to be that since it was spoken in the age of idolatry, when images were used for distraction or were attributed magical powers, the artist was rightfully considered responsible for causing distraction away from or interfer-

ence preventing the unity with God. Once these obstacles were removed, pictures of human beings became as harmless as those of trees and plants.[7]
...On the whole I think that the Islamic Law (Shari'a) is far from prohibiting one of the best educational methods (art) once it was proven of no harm to either religious belief or ritual practice.[8]

These statements by no less than the Mufti of Egypt himself were taken as a sign of encouragement by Prince Yusuf Kamal who, in a gesture of great largesse, founded the School of Fine Arts. The school opened on May 12, 1908, in Darb al-Jamamiz and was financed by the Prince for almost twenty years thereafter. Instruction was provided free to talented Egyptian youth with no prerequisite but the will to learn. Among the first graduates of this school were Mahmud Mukhtar, Raghib Ayyad and Yusuf Kamil. With others like Mahmud Said and Muhammad Naji, they formed a nucleus of Egyptian talent which in retrospect came to be called The First Generation.

Neo-Pharaonism
The earliest phase of modern Egyptian art is most strongly characterized by the movement known as Neo-Pharaonism, marked by a reformulation of ancient Egyptian style. Its greatest representative was the sculptor Mahmud Mukhtar, the first major figure in modern Egyptian art. Neo-Pharaonism and Mukhtar's relationship to it raise certain questions. Was it an autonomous and national insurgence, genuinely motivated by historical necessity or was it more in the nature of a passing trend, borrowed from an "Egyptian vogue" in Europe? Before considering Mukhtar's career, it is necessary to examine Neo-Pharaonism in the light of the cultural interchange which preceded the modern Egyptian movement.

In his book, *The Egyptian Revival*, Richard Carrott observes that, by the time the obelisk and the sphinx were used by Bernini in the seventeenth century, "the continuation and the exploitation of these motifs down to the nineteenth century held an echo of Ancient Egypt, but they had become so familiar outside of the Nilotic Ambiance that it can hardly be claimed they were solely the property of a pure Egyptian tradition."[9] This stylistic convention was challenged in the eighteenth century by the Romantic movement's passion for travel. The first artists to land in North Africa were in search of something they believed to have lost, the original beauty of antiquity. They were followed by others with a more glorious ambition: the Napoleonic Expedition to Egypt of 1798 This colonial enterprise led to the publication of the *Description de l'Egypte*, in twenty-one volumes, and to further diplomatic contacts. By 1822, Champollion had succeeded in deciphering the ancient Egyptian language. These events reawakened artistic interest in the civilization of the Nile and opened the door to yet more visitors and artists.

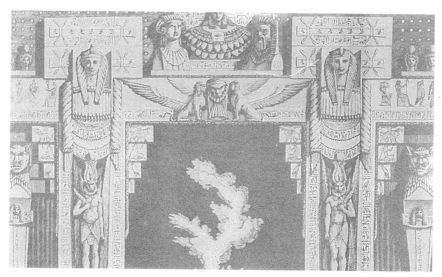

Fireplace design by G.B. Piranesi, 1769

Fountain in the Rue de Sèvres,
by J.M.N. Bralle

In France, Vivant Denon's illustrations in the *Description* were immediately taken up as decorative motifs in the Premier Empire style which spread throughout Europe. In architecture, however, Denon's plates had more influence outside France, in England and the U.S. Romantic Classicist architects responded to Egyptian monuments by projecting onto their simplicity and scale their own notions of the sublime. Egyptian Revival architecture achieved the Pharaonic simplification of structural geometrical form "in suppressing the triangular pediment shape of Greek architecture, and the curves of Roman domes and arches."[10]

If among other accomplishments [the Egyptian style] was to represent a final crystalization of Romantic Classicism through hypersimplicity, sharp geometry and clear symmetry, these qualities were to fall from popular taste by mid-century, but they were not lost. They reappeared in the work of later decades, be it in McKim, Mead and White, or Mies van der Rohe and [§] Philip Johnson.[11]

Mount Auburn Cemetery, Massachusetts, by J. Bigelow, 1831

Pennzoil Building, Houston, by Philip Johnson and Associates, 1977

Artists like Denon and David Roberts were followed by waves of Orientalist painters including some who, like Gerome and J.F. Lewis, documented what they saw with almost photographic precision. As early as 1849, Maxime du Camp and Gustave Flaubert used the camera itself to record their Egyptian travels in photographic albums published in 1852. It was the beginning of a tradition carried on by others like Robertson, Frith and the brothers Bonfils.

The rapid accumulation of Egyptian artifacts in European museums and private collections, and the successful work of archaeologists and linguists caused a widespread popular interest in Ancient Egypt which also had an impact on painting, as in the work of the Dutch artist Jan Toorop, for example. This enthusiasm was to turn into a veritable tidal wave with Howard Carter's discovery, in 1922, of the tomb of Tutankhamon.

That momentous discovery was also deeply felt in Egypt where it stirred feelings of a mystical past that was neither Muslim nor Christian. Pharaonism was also seen as the spirit manifested in the eruption of the peasantry in the 1919 demonstrations for independence, demonstrations that coincided in time with the first major exhibition of Egyptian artists in Cairo, also in 1919. In 1921, the Egyptian Society of Fine Arts was founded and, in 1923, the Society of the Friends of Art. Then, in 1927, the group which called itself "La Chimere" held its first exhibition. This was the group surrounding Mahmud Mukhtar; it included, among many European and Egyptian artists, Mahmud Said, Raghib Ayyad and Muhammad Naji. Attending the exhibition were journalists and writers who belonged to the "Society of Friends of La Chimere," organized by Husayn Haykal, editor of the liberal paper *al Siyasa.* Certain ladies of high society were also in attendance. These generous patronesses of the arts were outspoken feminists involved in the struggle for the emancipation of women initiated by Mrs. Huda Sharawi Pasha.

These various groups formed part of a cohesive cultural movement whose concerns can be found embodied in the symbol of the *fellaha*, (peasant woman) a symbol with three key elements: woman (beauty, art), veil (feminist emancipation), peasant (the land, nationalism). These ideas were intermingled in the common belief, developed by important literary figures like Tawfiq al-Hakim *(The Cave Dwellers, The Return of the Soul)* and Taha Husayn *(The Future Culture in Egypt, On Pre-Islamic Literature),* that the new Egypt would emerge out of a dormant Pharaonic-Mediterranean past, and that Islam was only a phase in Egypt's historic evolution. The paper *al-Siyasa* devoted considerable space to articles dealing with various aspects of life and culture in ancient Egypt, including trade, language, the family and clothing.

Husayn Haykal himself thought that the geographical position of Egypt had always ensured the survival of a distinctive national character. In his

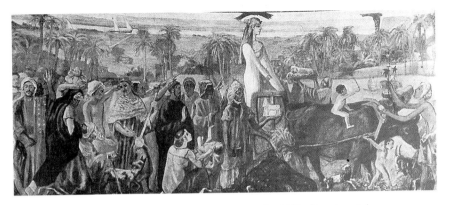

§ Muhammad Naji *Renaissance of Egypt* (mural), 1935, Senate, Cairo

Detail of *Renaissance of Egypt*

Detail of *Renaissance of Egypt*

memoirs, reprinted in 1927, he criticizes those Egyptians who are proud of their European, Turkish or Arab ethnicity. Instead, he proposes that Egyptians by birth should not recognize any homeland other than Egypt, and condemns those who claim descent from bedouin Arabs "driven by accident to Egyptian soil."[12] He notes with approval, after visiting an exhibition, that the artists adopt the simplicity of ancient Egyptian art, and exhorts them to draw their inspiration from the history of Egypt, particularly from Pharaonic mythology. He concludes that it would be easier to establish a national art than a national literature because "writers in the past and still in the present are committed to the imitation of the Arabs, although this imitation has been detrimental to their own personality."[13] For, unlike their artist compatriots, their inspiration is derived not from nature but from books: for this, the educational system is partially to blame. Haykal complains that young Egyptians are kept in ignorance of the literature of their Pharaonic ancestors, while being taught to admire the beauty of either Europe or Arabia. The right to free thinking, he claims, is not enough; it is the right to free feeling that needs to be restored.

The comments above make clear that Neo-Pharaonism was not a passing

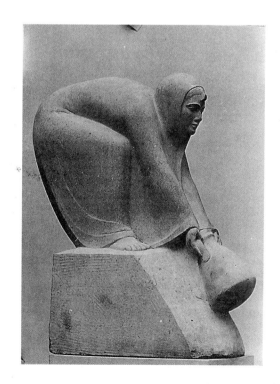

Mahmud Mukhtar *Fellaha Lifting Jug* (limestone), 1929, Mukhtar Museum, Cairo (photo: author)

trend but a necessary step. It established a common ground and history among small liberal factions who were otherwise divided along lines of race, religion and culture, The interest in Neo-Pharaonism lasted as long as these forces were able to stay united, and faded when they were divided by internal political conflicts. One might even argue that Neo-Pharaonism is the rallying flag of Egyptianicity.

The work of the group "La Chimere," mainly reflected in the art of Mukhtar, did not depend on the approval or support of a compatible western taste (the "Egyptian vogue") to affirm itself. Indeed, from Mukhtar's perspective, even in Paris, it appeared that Europe had been borrowing a great deal more from Egypt than Egypt ever had from Europe. Such, at least, was the situation up to the 1930s; after the 30s, that lead was lost.

Mahmud Mukhtar (1883-1934)

When I was a child, there had been no sculpture and no sculptor in my country for more than seventeen hundred years. The images that appeared among the ruins and sands at the edge of the desert were considered to be accursed and evil idols— no one should come near.[14]

Mahmud Mukhtar

Mukhtar was born in 1883 and grew up in the village of Nicha. He was a precocious child who displayed an early talent for modelling forms out of mud imbued with Nile water or clay dried in the hot sun and baked in bread ovens. The forms he created enacted ancient folk tales. They were named after heroes like Antar and Diaz, and Abu Zayd el-Hilali whose epics were sung by the village story-tellers.

When he was eight years old, he entered the *kuttab* school where he learned reading, writing and the Koran. It could have ended there, but he was destined to be among the few country boys who reached the centres of advanced education in Cairo, and were able to pass through the narrow gate of higher learning. Among them were Muhammad Abduh, Ahmad Lutfi al-Sayyid, Ahmad and Saad Zaghlul and Taha Husayn. Mukhtar was in Cairo when he heard about the new School of Fine Art founded by Prince Yusuf Kamal. Responding to a desperate urge to learn more about sculpture, he walked through the gate of the school and asked the first person he met if he could study art. That person was Mr. Laplagne himself, director of the school and professor of sculpture. Mukhtar was seventeen years old.

That encounter between Mukhtar and Laplagne marked a crucial turn in the life of our national sculptor. Laplagne, in fact, accomplished almost religiously the mission assigned to him. We could never speak enough of the positive influence this French artist had on Mukhtar throughout his life. He encouraged in his pupils all

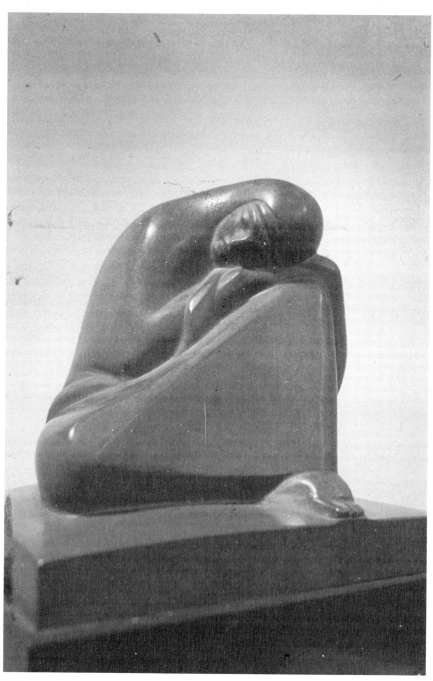

Mahmud Mukhtar *Siesta* (red porphyry), early 1930s, Mukhtar Museum, Cairo
(photo: author)

the moral values that make a truly great artist: the taste for freedom and independence, the love of the beautiful and great, the sense of justice and truth.[15]

This idealism and the earlier love for the heroic epics of Egyptian Arab folklore were welded together by the torch of political nationalism lit by Mustafa Kamil. This idealism became a spiritual force, emerging through the content of his sculpture as a form of middle eastern humanism. Mukhtar's ability to translate it into three dimensions is to be regarded as his greatest and most truly personal attribute.

As a reward for the success of his first exhibition, Mukhtar received a scholarship to Paris, thus becoming the first Egyptian to step into what appeared to him a wild place: the École des Beaux Arts in Paris. For that privilege, he paid the mad price of the initiation ritual. Later, he enjoyed describing the event; his companions stripped him naked, covered him with paint, paraded him through the city dressed up as a Rameses, and dragged him to the annual Bal des Quatre Arts. He came out of those crucial moments transformed into a real *bohème* without a trace of oriental shyness:

When I woke up I had broken the nut shell, I was a new Mukhtar. I had gone through the ordeal, I was emancipated, I had lost my virginity, I was turned on, I was from now on a Parisian, a real one, from *Paname*, a student of the school, the only one, the unique.[16]

Meanwhile, he was receiving letters from Laplagne ("You have an important role to perform for your country...") and from Prince Yusuf Kamal: "You left here as an Egyptian, you must come back to us as an Egyptian..."[17] These stories help explain the paradox of Mukhtar, a man who was equally at ease in France where he would regularly exhibit at the Salon des Artistes Français, and in Egypt where he was counted among the greatest nationalist heroes of the country.

They also help explain his vivid nonconformity. While Mukhtar was involved in his most official and committed work, the statue § *Egyptian Awakening*, he wrote a letter to the functionary from the building branch who had to register him as a public servant so that he could obtain his allowance.

Mr. General Director,
In letters dated January 5 and 12 I am asked to provide two certificates of good conduct. Well, Mr. General Director, it happens that my conduct is bad. I have a bad temper. I was sentenced to 15 days in prison. Furthermore, I wear a beard and that is frowned on here. I am a bachelor and I frequent certain particular houses. You see, Mr. General Director, I am therefore condemned to never become a public servant, ever.
Please accept, Mr. General Director, the expression of my distinguished regards.[18]

This same humour emerges in his caricature sculptures and in his series of cartoon drawings which appeared in *al-Kashkul,* a satirical paper.
Mukhtar's playful aspect was balanced by his strong rationalism. He was by nature a romantic: this is evident from his early works, such as *The Beggars* (1911). That inclination, however, gradually gave way to a preoccupation with pharaonic formalism. This adoption of the ancient Egyptian structural style might be partially blamed for the stiffness of Mukhtar's later work, for example the high reliefs of the monument of Saad Zaghlul in Alexandria. On the other hand, the reliance on a set of principles provided him with the foundations of a pictographic language that was organically attuned to his forms. It was when he used the hieroglyphic dimension as a communication device that he gave us his best works. § *Egyptian Awakening* could be examined in this light:

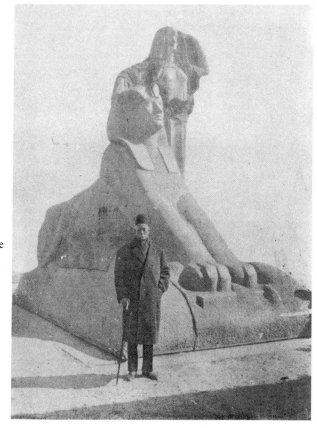

§ Saad Zaghlul,

leader of the Wafd

Party, in front of

Mukhtar's *Egyptian*

Awakening (pink

granite), 1919-1928,

Cairo University gate

(photo:

Sobhi al-Sharuni)

§ Mahmud Mukhtar *The Blind* (bronze), 1929, Mukhtar Museum, Cairo
(photo: Sobhi al-Sharuni)

Sphinx, you were the mystery of silence
But when the woman was added by your side
You became the mystery of utterance.[19]

The narrative quality of the statue is clear: it juxtaposes two pictographic
determinatives in one sentence (sphinx rising plus woman unveiling). Like a
hieroglyph, it calls for an objective and collective reading of the image. In this
way, it differs radically from European symbolism which is to be interpreted
subjectively, as in the art of Gauguin and Maillot for example. Therefore, the

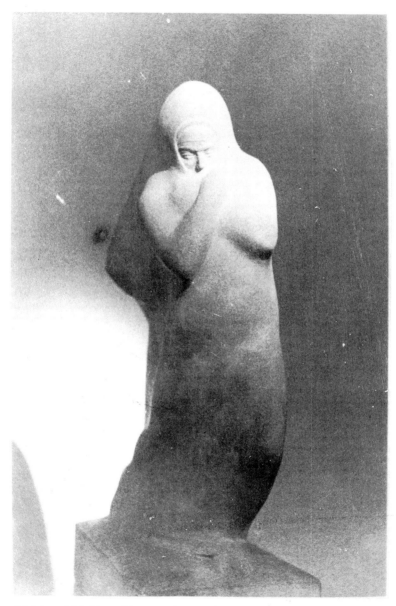

§ Mahmud Mukhtar *Khamsin Winds* (limestone), late 1920s, Mukhtar
Museum, Cairo (photo: author)

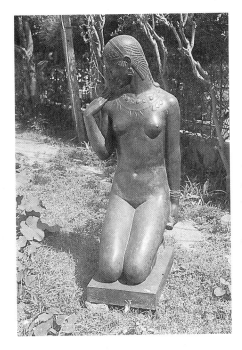

§ Mahmud Mukhtar *The Nile Bride*
(bronze copy of marble original in
the Musée Grévin, Paris), late 1920s,
Museum of Modern Art, Cairo
(photo: author)

communicative potential of the statue was great and the public response overwhelming and diverse:

> In *Egyptian Awakening*, Mukhtar gave the woman both national and social influence. Following her rising came the rise of a nation.[20]

> This statue was the first granite statue after the ancient Egyptians' statues. It was the first statue representing an idea and a symbol rather than the image of a king or a ruler.[21]

> The sphinx is a symbol of the pharaonic civilization rising with the Egyptian nation at its side, proud of its history. It removes its veil, revealing itself to the western people after centuries of disappearance.[22]

Mukhtar's life work reflected Egypt, and the Egyptian people identified a collective destiny in Mukhtar's sculptures. Rarely in history does one find such an intense nationalist awareness devoid of xenophobia. Mukhtar demonstrated with simplicity and without a trace of contradiction how western influences were adaptable to an Egyptian art. He experimented with Romanticism when he portrayed *The Beggars* and § *The Blind* (1929). He exploited futuristic principles of movement to give energy to the wind in his

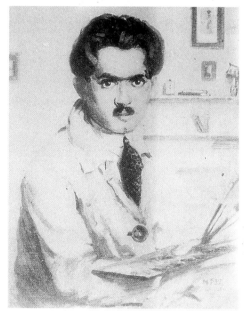

Mahmud Said *Self Portrait* (oil), 1919
(photo: author)

§ *Khamsin Winds* (late 1920s). He referred to Greco-Roman idealizations in his § *Nile Bride* (late 1920s). He exploited Constructivist angularities in his allegorical reliefs *Freedom, Constitution* and *Justice* (1930?) Finally, he played with caricature and satire infused with the humour of the traditional Egyptian folk character Juha. His vitality and confidence as an individual artist shone through all these phases of experimentation, accounting for his place as the first truly international Egyptian artist.

The struggle for the liberation of the idea of a modern Egyptian art had been won by Mukhtar, the extrovert. However, it remained for Mahmud Said, the introvert, to discover the limitations of his Neo-Pharaonist style through an undramatic yet difficult career dedicated to the liberation of feelings as subjective reality in painting.

Mahmud Said (1897-1964)

Said was always more concerned about expressing his own feelings than about providing us with intellectual gratification.

Ahmad Rasim

Mrs. Farida Zulfikar (Queen Farida of Egypt) describes her uncle Mahmud Said as a quiet, gentle, oppressively timid man, a *"fils de famille"* who suffered from lack of recognition by his family, not because they were indifferent to the arts but because, in those days, artists and even doctors were simply not among those people one invited to one's table.

Besides, they could not relate to his art. The closest they came to showing a sign of approval was when they acknowledged that it must be good because foreigners seemed to appreciate it.[23]

Said, however, is best described by his two § self portraits. In the first, dating from 1919, he appears as a very formal young painter destined to pursue a career in law. The second, from 1930, is more private and depicts him as a passionate, hyperlucid artist. In 1947, at the age of fifty, he resigned from his position as a counsellor in the Court of Appeals, to dedicate himself exclusively to his creative work. Badr al-Din Abu Ghazi explains that:

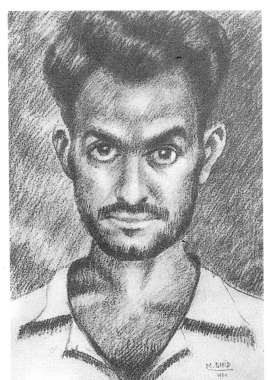

Mahmud Said *Self Portrait*
(pencil), 1930 (photo: author)

If the life of Said may have appeared peaceful on the surface, his inner life was torn between the values of his society and his personal desires, between limitations laid upon him by circumstances and his aspirations to freedom and self-fulfillment. He is one of those artists who were destined to integrate two conflicting vocations and ways.[24]

It is in that gap between restraint and passion, repression and desire that one finds the essence of Said's art. His paintings gradually became the space in which the range of contradictions of the Middle Eastern male express themselves through the clash between the pictorial rules of classical painting and the anachronism of Said's Alexandrian cultural imagery:

> Opulence and sensuality—such are the dominants in the painting of Said. He is the great Oriental lord, the man who paints for the joy of his exhilarated senses, who calls upon all the reminiscences of a refined culture without disdaining the humble daily spectacle that offers itself to us in the spontaneity of its moods or folkloric truth.[25]

By John Berger's definition, Said is a realist because his selectivity strives towards the typical: "Yet what is typical in a situation is only revealed by its

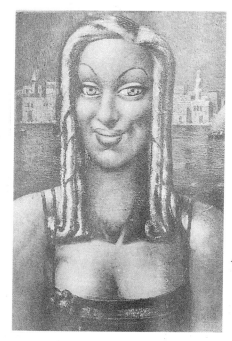

§ Mahmud Said *Girl with Golden Curls*
(oil), 1933, Hashem Collection, Paris
(photo: Sobhi al-Sharuni)

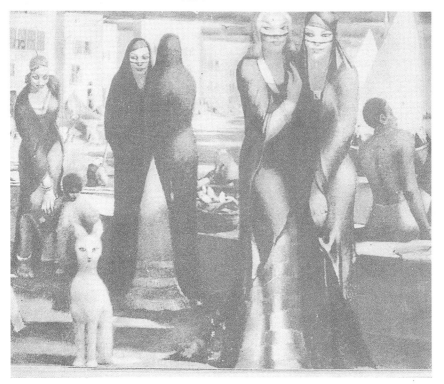

Mahmud Said *The White Cat* (oil), 1937, private collection (photo: author)

development in relation to other developing situations. Thus realism selects in order to construct a reality." As opposed to Naturalism, realism makes "a distinction between a submissive worship of events just because they occur, and the confident inclusion of them within a personally constructed but objectively truthful world view."[26] Unlike the naturalistic "Orientalist" painters who preceded him and who selected from events whatever increased their exotic impact, Said simplifies. Every figure is transformed into an archetype, regional in its existence but universal in its significance. Said works toward each transformation patiently, wilfully, lovingly. Thus, as Ahmad Rasim points out, "his painting is Egyptian in the most precise meaning one can give to the word. Said is not like those poets who think they can create oriental work by putting the Pyramids and the bedouin into their verses."[27]

Said's power lies in the rational control of feelings through the organization of his pictorial space in relationship to the sculptural forms of his figures. Every canvas is conceived as a stage, every figure as a performer. One might compare him to a master puppeteer modestly hiding behind his over-expressive characters, or define him as an inverted expressionist. Ramsis Yunan,

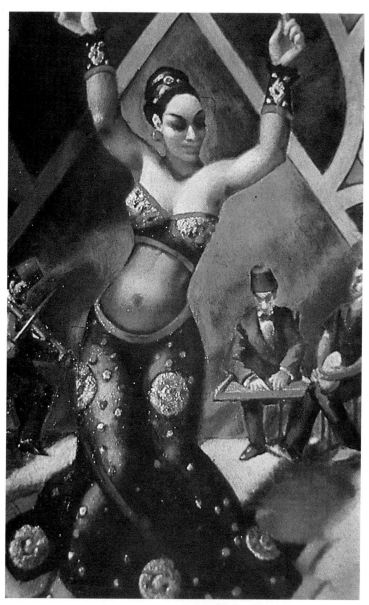

Mahmud Said *Dancer with Takht* (oil), 1949 (photo: Sobhi al-Sharuni)

the painter, observed that the painting entitled § *Girl With Golden Curls* attracts more by the strangeness of the subject matter than by the technique. "At first glance one feels that the creature painted is not a woman but a satanic being borrowing a human mask, expressing a confused thought, an enigmatic idea embodied by necessity in this material world. It is such images which reside in the subconscious and meet in our dreams."[28] This same level of imagery is to be found in his *Invitation to the Voyage,* in his hyper-aware donkeys, his erotic cats, the suspended quality of the woman's *milaya,* (black, enveloping gown) the eeriness of the seashores, the frozen movement of the figures and the high saturation of the colours.

Ultimately, Said is considered a painter's painter because he relishes difficult formal situations. This fine line between expression and analysis, where Said the painter meets Said the lawyer, results in the stylistic harmony of seemingly unreconcilable plastic elements: the roundness of the human figures and the recurrence of the diagonal axis clashing like swords in the centre of the canvas, the play of linear parallels leading the eye through the painting as through an arabesque, the chromatic treatment of colour as the major compositional device.

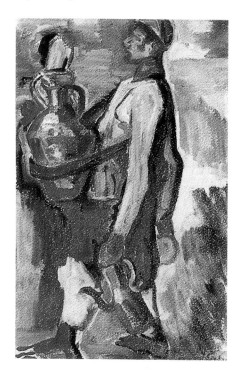

Muhammad Naji *Street Vendor*

(watercolour), early 1940s

(photo: Sobhi al-Sharuni)

Muhammad Naji *Ethiopian Court*
(watercolour), 1931
(photo: Sobhi al-Sharuni)

If Mahmud Said cannot be classified as Cubist or Expressionist, it is because his lines are ultimately intact and faithfully rendered on the basis of a direct observation of nature or the study of Renaissance painting. If only on this basis, Said should be considered a classical painter.

Also, it is in the formally intuitive attitude bearing as much on an Oriental taste for wealth or solid effects as it does on the Egyptian character discovering itself in the identification of a type and the simplification of the masses, that Said enters decorative painting in its baroque meaning. It proceeds from the Italian tradition and goes through all the paradoxes of which an Oriental mind is capable.[29]

How far this is from the simplicity of Neo-Pharaonist classicism! While Egyptian two-dimensional art was highly adaptable to the description of events or the communication of ideas it formalized design into rigid norms which left very little room for the expression of personal feelings. As a result, Pharaonism was not of great significance in Said's work: it was too restricting, the artist being mainly concerned with the plastic expression of his subjective feelings. Said was, however, able to draw from ancient Egyptian painting the features of an Akhnatonian physical type; a rapprochement between his con-

temporary veiled woman and the "tanagras" (Greco-Roman draped female statues) and, perhaps, a cognition of a timeless dimension in visual representation.

Muhammad Naji (1888-1956), Raghib Ayyad (1892-1980)

Two other painters of the "La Chimere" group explored the poetic realm of the rural environment. Raghib Ayyad, inspired by popular and folkloric themes, interpreted them in his paintings from an insider's viewpoint. Muhammad Naji portrayed Egyptians in all their ethnic variety, integrating his impressions in thematic and historic reconstructions. The two, however, shared the same formal limitations: their attempts to resolve the cultural and political ambiguities they encountered in the world and within themselves were limited to the stylistic conventions of European painting. Their art seems confined and stands more on the basis of its thematic content than on the innovative or distinctive character of their pictorial styles.

The critic Naim Atiya states in his book *Al-Ayn al-Ashika* that, of all the artists of the first generation

> Ayyad was the one who introduced us to folk society, to its markets, *zar* ceremonies, cafes, fields, public baths and monasteries. He exposed us to situations which were usually looked on with scorn by narrow-minded idealist painters. Ayyad's prolific career was entirely based on ethnic themes which he treated with such rough and warm vitality that it made him stand out among artists of his time.[30]

Ayyad was a witty observer of the tragi-comedy of human interactions. He saw it but also heard it in the din of popular events. He reacted to voices, music and noise in drawings which at times read like story boards: part musical notation, part caricature. In fact, his work is often compared to the music of El Sayyid Darwish, its earthy quality and emphatic feelings barely disguised by the occasional cynicism as in his § *Nubian Café* and § *Work in the Fields*.

Ayyad remained the Egyptian boy who graduated in 1914 from Prince Yusuf Kamal's school. Even the ten years (1920-1930) that he spent pursuing his art training in Italy did not erase his strong connection to his roots. That connection sustained in him, as in Mahmud Mukhtar, a profound sense of belonging to his native land. Indeed, that distinctive humour, rooted in popular parables and combined with social commentary, identified and culturally expressed his generation. Ayyad was an Expressionist by temperament, an inclination that was encouraged by his exposure to Coptic art during the years when he was a Director of the Coptic Museum. From that artistic tradition he learned to emphasize graphic elements through the bold tracing of contours and the thickening of his colour paste which he laid on in patches like a thick encaustic medium.

All these qualities explain why Ayyad, of all the teachers of his period, had the greatest influence on the painters who succeeded him.

Muhammad Naji was born in Alexandria in 1888. After graduation from the University of Lyon, he chose to dedicate his life to art. Unlike Said, another Alexandrian, he experienced the conflict described by Elian J. Finbert as "the spiritual drama acting itself out in the soul of certain orientals who feel torn between east and west. Having heard the call of their past, they answered it but were unable to avoid the seductions and traps of the west and could not resist responding to them."[31]

Naji spent most of his life abroad. His continuous travelling—even in his homeland where he set up studios in Luxor, Memphis and Alexandria—was the consequence of an insatiable curiosity and was most probably the best outlet for a deep anxiety never fully expressed in his painting. Aimé Azar explains the mystifying qualities of Naji's paintings as the result of the artist's personal ambiguity: "a humanist unaware of his exuberant lyricism, a poet colliding with the intellectuality of painting and its norms."[32] Naji's somber aspect and his deep conviction that the solution to his artistic quest might not only lie in the west or under the desert sands but more likely beneath the black earth of Egypt is revealed in the following two statements from a speech he made in Prague in 1928:

I see ourselves affected by a spleen without remedy. Disillusioning travels would only drive us to exasperation.[33]

When the health of a society runs out, it is up to the people close to the nourishing origins of the civilization to feed it through its inexhaustible resources.[34]

Statements like these compelled Naji to resign from his post in External Affairs after his return from a diplomatic mission to Brazil in 1930. He left for Ethiopia, this time on an artistic mission. There, he discovered the chromatic harmony of warm colours contrasting with the dark African shadow, and studied Coptic religious and folk painting. He was able to reconcile that experience with the study of Egyptian tomb art and the tradition of the school of Fayyum; the latter is characterized by the use of colour as an essential value in portraiture, and by an acute penetration and expression of the inner personality of the subject. The lesson Naji drew from those two sources led him to his finest achievements in painting: his § *Bread Bakers* and his later *Harvest of Cotton*. Elian J. Finbert wrote in a review:

He succeeded in bridging the gap with his ancestors. His paintings breathe the black rich earth with its continuous germination and its succession of life cycles. But, strangely enough, his paintings impress by their static strength, tamed and unmoving.[35]

In the years following his Ethiopian expedition, his work took on its most distinctive form. The change may, however, have started in Latin America where, one might speculate, he learned about the Mexican muralist movement and became acquainted with the writings of the brilliant educator J. Visconcelos, Minister of Education during the Mexican Revolution and a man who believed in the social mission of art. This may account for Naji's increasing involvement in mural painting and for his pedagogical orientation throughout his teaching at the Academy of Fine Arts. Al-Jabakhanji pointed out that "Naji's greatest dream was to see young painters able to decorate the walls of public buildings."[36] He himself showed the way in murals like the § *Renaissance of Egypt,* executed on the wall of the Senate in Cairo. It depicts an endless, slow and colourful procession. Horizontal in its composition and intercultural in the grouping of its figures, this work has the same dramatic energy as the Mexican murals. But it is fundamentally Eastern in the subtlety and gentleness of its poetic inspiration and in the meaning emanating from the procession which symbolizes historic motion.

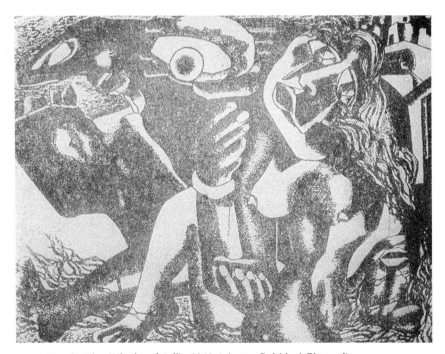

Fuad Kamil *The Whirlpool* (oil), 1940 (photo: Sobhi al-Sharuni)

Abdin Palace, royal residence: a bed in the Great Wing

TWO
The Cosmopolitans

The Second Generation

The art bequeathed by the First Generation was the flower of a movement led by a single unified party that included the most progressive forces in the country. It was the artistic expression of a resurgence of positive national awareness and it was art that "made history." The situation changed noticeably between 1935 and 1945 when artists found themselves caught between the confusion of wars in Europe and the resulting political breakdown at home. The cultural and political insecurity of this second generation resulted in the expression of ideas in art forms which were essentially a reaction to history.

In response to the dogmatization of art in both Nazi Germany and the USSR, this second generation launched the slogan "Long Live Low Art." They dealt with the less than reassuring partisan situation at home by withdrawing into Marxist ideology, an ideology strongly diluted in their case by liberal cosmopolitanism:

> They loathed the bourgeoisie which was free from the struggle of the poor and the golden fetters of the rich...They found the solution in Communism. It was not, however, working class communism but ruler's communsim: communism of thought, not reality.[37]

Politically, three separate forces affected the independence of this artistic movement, forces that had started as minor organizations in the 1920s and eventually grew as the result of widespread disillusionment with the government, mainly among the youth. With the outbreak of World War II and the emergence of the Palestinian question in 1936, the ideological opposition developed into organized parties with strong cultural repercussions. The first, Young Egypt (1933) was a nationalist martial organization vaguely modelled on Fascist Youth. Known as the Green Shirts, it prompted the values of morality and heroism, and aimed at reviving a glorified version of the Arab-Pharaonic past.

The second was the Muslim Brotherhood (1928) which advocated an anti-modernist, anti-western model of society and politics based on orthodox Islamic views. It was militant and pan-Islamic.

The third was the internationalist pro-Bolshevik left. Many of its memberes were European residents in Egypt. They rallied around the Socialist

Party (1920) and the Communist Party (1922). Their main objectives were the organization of labour unions, opposition to the British protectorate, and programs for economic and social reforms. Besides offering a challenge to the ruling Wafd Party, their form of new radicalism attracted the sympathy of such prominent intellectuals as the novelist Najib Mahfuz, Luwis Awad the cultural historian, Rushdi Salih the folklorist, Albert Cosseri the writer, and many artists.

Aimé Azar describes Cairo in the late thirties as an intellectual crossroads comparable to Paris or London where international artists with or without uniforms (Lawrence Durrell, John Fleming, Cyril des Baux etc.) interacted with young Egyptian painters and writers within an active cosmopolitan scene:

> In Egypt, the clash of ideas external to art, the dramatic creative experimentation taking place, the contradictions raised by a multiplicity of enthusiastic voices, all triggered in the artist of that period of transition a sense of commitment which tied him to his people and led him to realize the necessity of stability and cohesion in what he was and in what he was trying to do.[38]

In fact, regionalist preoccupations and the search for a distinctive local art were at the core of what seemed like a total adherence to international ideas about art. In 1937, al-Talmissani wrote: "If I can only find the first traces of a new local art, then I will consider myself an artist."[39]

The new artistic language to which these men aspired had to extend its stylistic formal boundaries to allow more creative freedom; to find it, artists were willing to literally try anything. Everything led them away from the society of the "Friends of Art" who patronized the official salon. The avant-garde viewed this salon as the epitome of sterile academicism: its exhibits promoted an art that did not account for the reality of artistic expression in relation to its formulation. The avant-garde believed that images ought to be extensions of the cognitive process, carried to the canvas by the power of the imagination. This intellectual approach to the creative arts was expressed in such forms as group exhibitions of the society known as "Les Essayistes" (1934-1935) and in such art journals as Un Effort, edited by poet and polemicist Georges Hinayn. Hinayn also organized the group "Art and Freedom" in 1938. Begun as a rejection of Fascist art, following a debate honouring the poet Marinetti, the group turned into an alliance with André Breton and Diego Rivera who, in Mexico, launched a manifesto entitled "For a Revolutionary Independent Art." Hinayn's December 1938 manifesto, "Long Live Low Art," was signed by thirty-seven members including Ramsis Yunan, Kamil al-Talmissani and Kamal al-Mallakh. It opposed the oppressive measures of Fascism (such as the censorship of Klee, Ernst and Kandinski by the Nazis) and stressed the individual imagination as the greatest

revolutionary force, the artist's political asset which he ought to express freely and creatively.

Concern for international affairs and the wish to actively participate in the collective international resistance against cultural oppression emerged again in the bulletin introducing the 1940 exhibition of "Art and Freedom" which

Abdin Palace, royal residence: Byzantine Hall

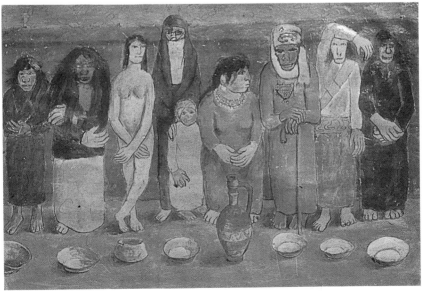

Abd al-Hadi al-Jazzar *The Theatre of Life* (oil), 1948, artist's collection (photo: author)

§ Abd al-Hadi al-Jazzar *Street Theatre* (oil), 1947 (photo: Sobhi al-Sharuni)

included Mahmud Said, Ramsis Yunan, Fuad Kamil and Aida Shihata:

> While people around the world are attuned to nothing but the sound of cannons, we find it our responsibility to shelter and promote artistic trends which vitally express the idea of freedom.[40]

After his return to Egypt from France as a sign of his opposition to the Suez invasion in 1956, Ramsis Yunan (1914-1966) spokesman for the "Art and Freedom" movement wrote an essay defending the aims of the group and the necessity of linking local art with the international artistic heritage:

> Although it was essentially a Surrealist movement, "Art and Freedom" welcomed different other artistic trends. It also helped relate the Egyptian artist to the contemporary world, and relate the concept of art to the concept of freedom.
> Thanks to the Surrealist movement, more attention was given to our folklore heritage which, as a result, became the inspiration of some Egyptian artists long before Tawfiq al-Hakim wrote his play *The Tree Climber.*
> "Art and Freedom," unlike other propaganda, did not call for confinement within the limits of tradition, without any true understanding of our heritage or the international heritage.
> It is often said that modern art became international as a result of colonialism, which culturally as well as militarily invades the colonized countries, thus destroying their traditions and their arts. However, we should realize that modern Euro-

pean art had been influenced by Eastern and African arts before any Eastern or African artist was influenced by European art. Therefore, cultural invasion is not the issue, it is rather cultural response, expressed in breaking out of the boundaries of national tradition into the international heritage.
True Egyptian art will not exist unless our past heritage is allowed to react with the international heritage: only that will lead us to establish the foundations of our modern art. Therefore, we should not fear any innovation, no matter how extreme it may be, for those who fight innovation under the pretext of protecting our national identity reveal the weakness of their faith in its potential for growth.[41]

Yunan's writings throughout the 1940s helped transfer the aesthetic debate from the level of content-interpretation within the accepted norms of formalism, to a mediation beween content and form with styles developing from psycho-social realities seeking expression in art as content. His painting, as well as that of Fuad Kamil, gradually evolved from Surrealism to Abstraction. The transformation was slow because of the resistance they faced in the mid-30s from a public unwilling to abandon a figurative tradition that had so recently been established in Egypt. Figurative art was now rooted in the public taste; anything else was perceived as counter-cultural. This attitude was encouraged by a ruling class which identified with its conservative bourgeois counterparts in Europe, and was institutionalized in the Academy of Fine Arts which acknowledged only works of art from Da Vinci to Monet. Private collections owned by connoisseurs and wealthy families included classical oil paintings which were considered mainly as beautiful *objets d'art*. They included the works of Orientalist painters and academic artists like the sculptors Antun Hajjar, Uthman Disuqi, Muhammad Hasan, and the painters George Sabbagh, Ahmad Sabri, Yusuf Kamil, etc. (Most of these large collections were scattered after the revolution. The one owned by Muham-

Abd al-Hadi al-Jazzar *Wild Woman* (ink), 1942
(photo: Sobhi al-Sharuni)

mad Mahmud Khalil, however, survived by being willed to the government in 1952 and is preserved as a museum in Zamalek. The collection was assembled largely by French experts and includes masterpieces of Rodin, Delacroix, Ingres, Renoir, Van Gogh, Gauguin, and hundreds of other well-known European artists.)

The Moslem establishment's dislike of abstract art was ironic because Islamic art (calligraphy, miniatures and design) was a major source of inspiration to the great creators of the European movement away from representational art. As Michel Hoog remarks in an essay entitled "Autour de 1900":

> Matisse, Klee and Kandinski, to name a few, searched in Islamic art for another artistic world: that is to say, a world not constrained by the conventions of Western art, defined by the Italian Renaissance and degenerated after four centuries of use. [42]

On the other hand, the scholar Bishir Faris defines Islamic art as an adventure in non-figuration dictated by a rejection of the Pythagorean idea of man as "the measure of all things." The Islamic artist opts for an aesthetic process rooted in religious transcendence: an art based on harmonies of the formal elements of line, surface and colour arranged according to a mathematical perception of time and space. His intention is to attain the visualization of a thought which does not represent man or nature but life understood as energy and motion. [43]

The painter Fuad Kamil (1919-1973) was aware of this Islamic perception of art when he defended his expressionist abstract style:

> The artistic element absorbing all the radiations emanating from the self and the imprints of the cosmic order is finally the surface of the canvas itself. It is on that surface that the traces of tension, pressure, contraction and diffusion flow. [44]

Kamil's intellectual message was fully grasped by the abstract calligraphic artists who worked from the mid-60s onward: Ahmad Fuad Salim, Husayn al-Jibali and others.

The Second Generation, as represented by "Art and Freedom", raised the issues of both internationalism and regionalism in modern art while it also challenged nationalism and artistic academicism. In so doing, it alienated the majority of the public and lost financial and political support. This second generation is now mainly remembered for the anachronistic and at times dilettantish manner in which its members embraced every wave of "isms" (Expressionism, Surrealism, Cubism, etc.). They eventually succeeded, however, in transforming artistic creativity from outwardly social and nationalist themes to a world of inner poetry and self-realization. The consequences of this individualization, so contrary to the socio-cultural foundations of trad-

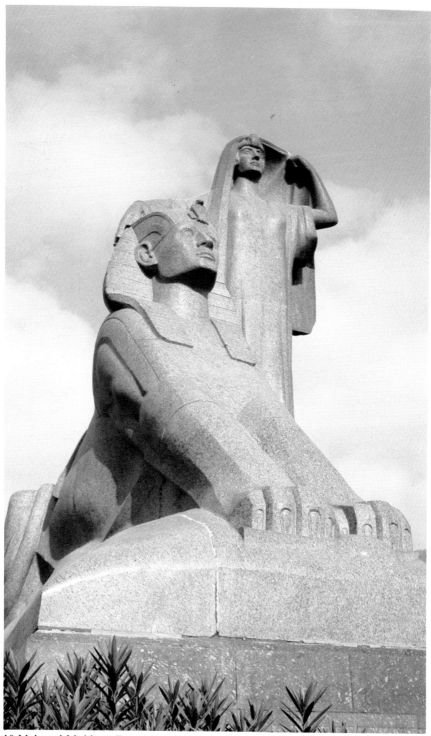

1§ Mahmud Mukhtar *Egyptian Awakening* (pink granite), 1919-1928, Cairo University gate (photo: Sobhi al-Sharuni)

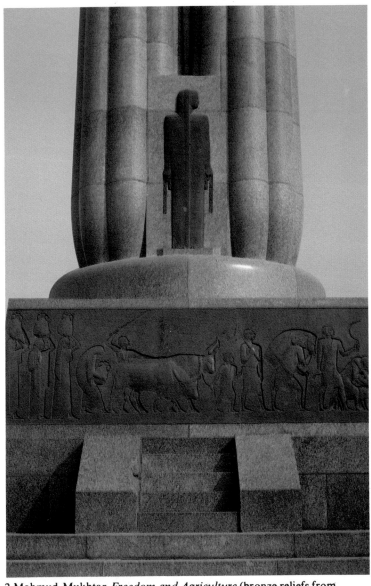

2 Mahmud Mukhtar *Freedom and Agriculture* (bronze reliefs from the granite monument to Saad Zaghlul), early 1930s (photo: author)

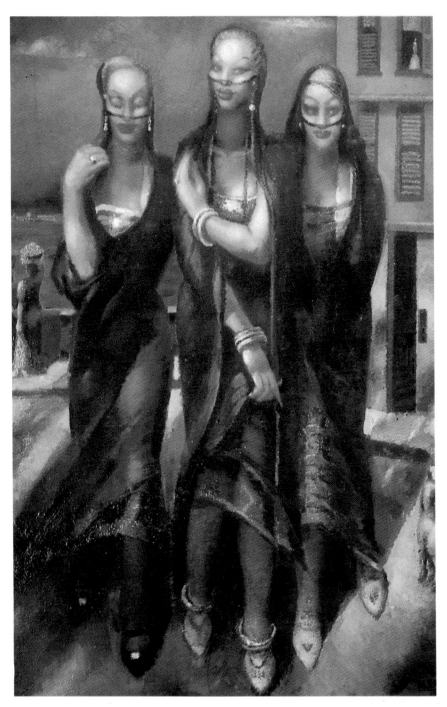

3 Mahmud Said *Banat Bahari* (oil), 1937

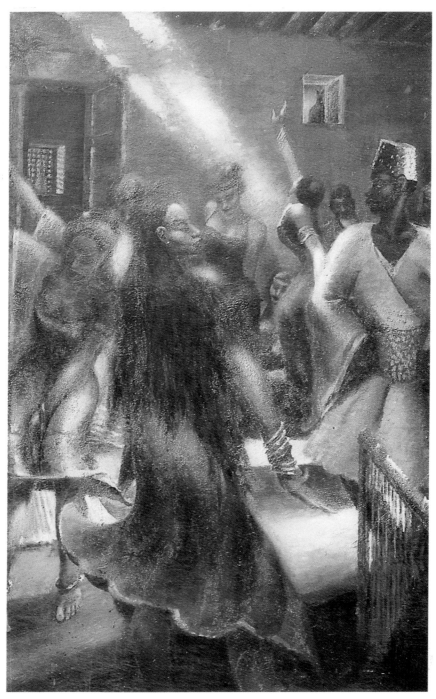

4 Mahmud Said *The Zar,* detail (oil), 1939, Museum of Modern Art, Cairo

5 Mahmud Said *Prayer* (oil), 1941, Museum of Modern Art, Cairo (photo: Sobhi al-Sharuni)

6 Mahmud Said *Matruh Bay* (oil), 1950 (photo: Sobhi al-Sharuni)

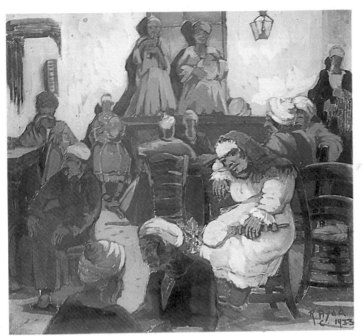

7§ Raghib Ayyad *Nubian Cafe* (oil), 1933,
Museum of Modern Art, Cairo (photo: author)

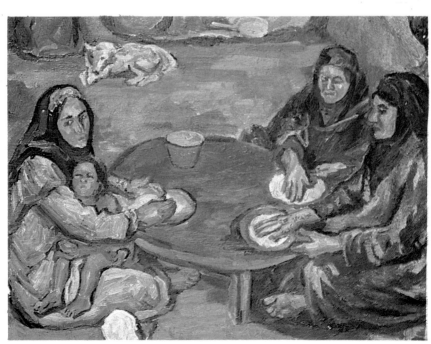

8§ Muhammad Naji *The Bread Breakers,* detail (oil), 1934, Museum of Modern Art,
Alexandria (photo: author)

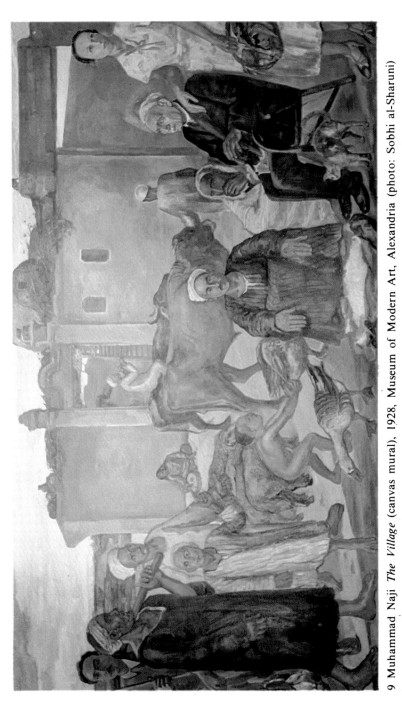

9 Muhammad Naji *The Village* (canvas mural), 1928, Museum of Modern Art, Alexandria (photo: Sobhi al-Sharuni)

10 Raghib Ayyad *Work in the Fields* (oil),
1934, Museum of Modern Art, Cairo
(photo: author)

tional Arab society, appear to be the real basis of the controversy which they raised. It was up to the Third Generation to actually resolve that conflict.

It is not enough to realize that a new art is born with every generation. We should be aware that the same happens with every newborn baby.[45]

Fuad Kamil

The struggle of this second generation avant-garde for the liberation of individual self-expression bore its true fruits in the better understanding of the fundamental language of forms and in the field of art education.

Art Education
At the beginning of the twentieth century, the vast majority of Egyptians who became literate did so in the religious *kuttab* schools which were extensions of the Azharite institutions. A few who could afford it went to missionary or private schools which provided almost no instruction relevant to Egypt. This situation was general until 1940, when a law was passed requiring all foreign schools to teach Arabic, Islamic religion and history to all Muslim students. Meanwhile, when elementary education became compulsory, there was also an expansion in public education. By 1940, twelve percent of the national budget (as opposed to one percent in 1920) was allocated for education. Although the quality of the state-controlled art program was uneven and its purpose more instructional than educational, it provided a system in which a few dedicated art educators were able to apply basic pedagogical theories to the teaching of drawing. Yusuf Afifi, Habib Jurji and Husayn Yusuf Amin were pioneers in this field.

Afifi taught drawing at the school of Saadia, where his pupils included Fuad Kamil and al-Talmissani. An extremely dynamic personality inspired by John Dewey and Herbert Read, Afifi influenced the theoretical lines adopted by the Faculty of Art Education, established in 1930. Along with Amin, he also founded the Union of Drawing Teachers in 1937.

Habib Jurji was exposed to the teachings of Herbert Read in England. When he returned to Egypt, he began an educational experiment to demonstrate that every child is a natural artist whose creativity will spontaneously develop into an original talent, provided that the child is encouraged and given the appropriate technique. In Jurji's school the children who came from *fellahin* families were allowed to explore the medium of clay modelling without direct instruction or critical feedback. Jurji chose clay because it was simple and available to the children. This same school became very famous when it was expanded to include fabric arts by Jurji's son-in-law, Ramsis Wissa Wasif. It is now the world-renowned Centre for the Arts where the highly valued tapestries of Harraniya are produced.

The most significant of this pedagogical generation, Husayn Yusuf Amin was above all an artist. He was also a man of vast culture, acquired through extensive travel in Europe and in Brazil, where he lived for several years. After his return to Egypt in 1930, he began a successful career as a painter, a career which he abandoned to dedicate himself to teaching. All art historians agree that he was the man behind the spectacular development of Egyptian art which began in 1946.

Amin's interest in pedagogy caused him to follow his pupils from secondary school through to their graduation from art school. It even led him to become an art theorist when he defended his students' work in response to the violent polemics they raised. Amin held the deep conviction that nationality was not an aesthetic but that the work of art gave nationality its character and allowed it to be discovered and understood by others. If these works of art came from the popular milieu, isolated by social underdevelopment, then they were likely to convey a revolutionary aesthetic and a message with profound social implications. From that conviction sprang his commitment to work with students who came from backgrounds totally excluded from the established mainstream of art and culture, and his intention to make this new art conquer that establishment.

He succeeded. When his students, calling themselves "The Group of Contemporary Art," opened their first exhibition in 1946, it proved to be a cultural and political explosion. In 1949, Amin and the painter Abd al-Hadi al-

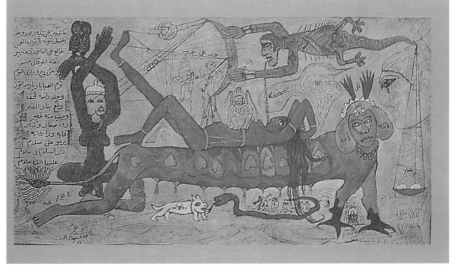

Abd al-Hadi al-Jazzar *Folk Poem* (tempera), 1953, Museum of Modern Art, Cairo (photo: author)

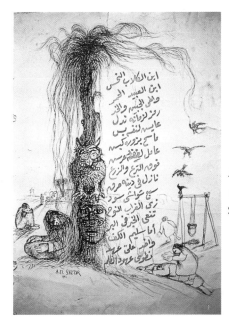

Abd al-Hadi al-Jazzar *Poem* (ink), early 1950s, artist's collection (photo: Sobhi al-Sharuni)

Jazzar were arrested because the latter's painting *Hunger* (re-entitled § *The Theatre of Life*) was considered an attack on the political system. However, both were released following the intervention of Mahmud Said and Muhammad Naji, who used their influence to have the charges dismissed.

The true revolutionary impact of Amin's contribution was not the result of a theoretical radicalism, but the product of a remarkable intuition. The images his students created were not influenced by his direct instruction but probably would never have existed without his insight. And in effect this phenomenon was repeated on the larger social canvas. Aimé Azar writes of the contribution of the Group of Contemporary Art to the Revolution of 1953:

The young Egyptian Revolution has been, in some way, the result, the confirmation and the triumph of the social consciousness represented in the work, the message and the pressure coming through the expression of young Egyptian painters.[46]

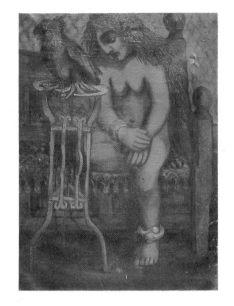

§ Abd al-Hadi al-Jazzar *Woman with Khulkhal* (oil), 1951, artist's collection (photo: author)

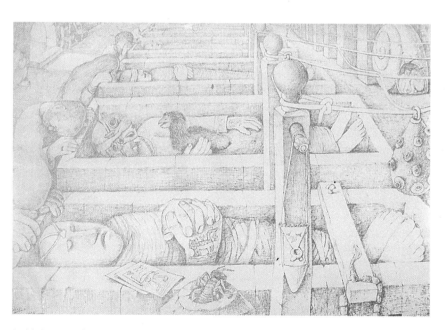

§ Abd al-Hadi al-Jazzar *World of the Spirits* (ink), 1953 (photo: Sobhi al-Sharuni)

THREE
The Folk Realists

The Third Generation

In the years preceding the Revolution, a third generation of Egyptian artists arose. Unlike the previous generation, which had taken a militantly partisan stand on the political crisis, this new generation withdrew from the ideological debate. In so doing, they formed part of a massive desertion of intellectuals from the political arena, a desertion that portended imminent popular uprisings and suggested that any reformist initiative would come too late.

This third generation turned away from the cosmopolitan art now favoured by the ruling class, and concentrated on creating a new rapprochement between the people and the educated classes: they devoted their attention and talent to the development of grass-roots artistic formulations. Edmond Muller observed in 1950:

> The art which is familiar to society today does not express Egyptian reality; instead, it is affected by diverse influences which are merely juxtaposed to our reality. Some artists are aware of that situation and they attempt to restore the bridge between art and life, or to relate the sources of inspiration to the sources of Egypt.[47]

"The sources of Egypt" were neither landscape nor Egyptian physical types but rather the popular attitudes that reflected the situation of underdevelopment attributable in large part to the political infrastructure. Popular beliefs, affected by fear, repression, illness and poverty, but also revealing the vitality, character and potential of the nation were concentrated in the ethnic and folk arts. In them, the folk-realist painters of the third generation felt the combined essence of a subjective surrealist aspect and an objective realist content. However, folk arts capture the Egyptian condition anonymously: the folk artist generally subordinates his individual creativity to a set of standard cultural stereotypes. The folk-realist painters consciously avoided this subordination. They focussed primarily on reality, viewed from their own perspective and expressed in their own individual language. It was their interest in realism which independently led them into the streets, perhaps to the same alleys and mudbrick villages visited by novelists like Najib Mahfuz (*Midaq Alley, Khan al-Khalili*), Yahya Haqqi (*Lantern of Umm Hashim*), Abd al-Rahman al-Sharqawi, Yusuf Idris, and other writers and poets. Mahir Raif emphasized reality as the primary criterion:

47

I cannot sense a definite influence of Egyptian style on our contemporary art. Personally, I want to express the present reality, for we must not live in the past. However, in the measure that art plays that role, it is likely to interpret the context which it is called upon to modify.[48]

The social aspect of the folk-realist group's attitude can be attributed to the pedagogical training these artists received. On theoretical grounds, art education contributes to art by focussing on the process of perception itself instead of relating the art work to history on the basis of its stylistic and formal attributes. In other words, theorists of art education approach art history as a continuous exploration of the human psyche and its forms of expression. This attitude pervaded the work of the Group of Contemporary Art, who understood history as the evolution of imagery, and contemporary painting as the reflection of a collective consciousness.

Furthermore, this generation attempted through their paintings to come to grips with the collective subconscious of the people, paralyzed by the effects of poverty, superstition and ignorance. To do so, young artists scanned the slums, trapped in the silence of a tragic fatalism, and expressed the dreadful conditions of the poor by claiming the darkness of interior spaces as the landscape they explored with the attentive eyes of anthropologists. Samir Rifai, speaking of al-Jazzar, describes this anthropological search:

Cruising the slums of our large cities, Jazzar captures the curious events, the unexpected attitude, the grotesque forms, the whole range of superstitions inherited from obscure times, which the natives drag along and use to defend themselves against evil spells. Like a scholar of folklore, he lays it all down in his painter's file. Back in his studio, he will transpose these scenes taken from reality onto canvas where they will, later, appear to us like visions from the subconscious. They will be expressed in simple colours, in grainy paste, and in a visual calligraphic style resembling the graffiti art covering the walls of the houses of the people, with all the overstatements used by those naive artists who created them in order to liberate their frightened consciousness in contact with the mysteries of existence.[49]

Imagery
The paleolithic symbol of the blood handprint, a Biblical protection against the wrath of Moses; the eye of Fatima, protection against the evil eye; the eye of Ra, the crescent moon, the Virgin Mary, the colour blue, the sacred turquoise stone, the colour green. The spider web, the undulation of the snake, the turtle shield, the lizard, the rat, the fish. The Apis bull, the winged Assyrian bull, the horse of Troy, the winged horse of the Prophet, the watch dog Anubis. The verticality of the palm tree, the solidity of the sycamore tree, wheat, dust. The scorpion, the key, the sword, the hashish pipe, the worrybeads, the playing cards. The human scale: distorted bodies like mummies,

baboons, foetuses. The naked woman and her opposite. The empty shell.
Hanging laundry.

The list is endless. On the canvasses, symbolic arrangements extend from
baroque surrealism to the clear order of Pharaonic documentation. In every
way, this generation's compositions strike one with their regional realism.
They affirm that modern Egyptian painting finally exists.

In order to fully grasp this special attention to traditional visual symbolism,
one must remember that, in Egypt, Islamic doctrine discouraged the use of
symbolic pictures for over twelve centuries. However, archetypal imagery of
ancient Pharaonic and Coptic origin persisted through the ages, crystallized
in the folk arts. There, it was schematically expressed in the signs and sym-
bols of the popular arts: mural graffiti, puppetry, amulets, religious crafts,
tattoos, costumes and ornamental design. As images became objects of
superstition and magic, they gained more and more symbolic power, thus
allowing them to maintain their archetypal force intact through the ages.

This counter-cultural role played by visual imagery placed the Egyptian
artist in a completely different position from his European counterpart. By
the twentieth century, the Western world had almost exhausted its own
resources of traditional visual imagery through centuries of over-use in art
and abuse in advertising. In fact, it is agreed that the gradual degeneration of
archetypes into clichés in the Western world was a major factor behind the
impulse to abstraction, the outrages of Dada and, with surrealism, the plunge
into the depths and the conscious cultivation of unreason.

In the East, however, the Arab artist was about to begin grasping his own
pictorial foundation. To the young realist painter of the Group of Contem-
porary Art, as to the social-realist poet of the new free verse movement, Mid-
dle Eastern symbolism was an untapped resource, a regional Ali Baba's door
which only Arab artists could unseal.

Mahmoud Said sensed that domestic animals like the cat, donkey and
dove, or everyday objects like the water jug or the fish net were elements
which performed, as images, an ambivalent role as in the magical mediaeval
folk tales of the *Arabian Nights.* But in the 1940s, the young painters of the
Group of Contemporary Art went even further. Jazzar and Hamid Nada
used their store of symbols both for their spiritual meaning and also as figura-
tive representations of the passage of time. In such works as Jazzar's § *Street
Theatre* or Nada's § *The Cat's Sleep,* the visual archetype becomes the symbol
of duration and endurance—witness to an immemorial past, both an inheri-
tance and a burden.

Abd al-Hadi al-Jazzar (1925-1965)
Among the students attending Yusuf Amin's art classes in the public secon-
dary school of El Hilmiya was a young artist, Abd al-Hadi al-Jazzar. He was,
to use Victor Lowenfeld's term, a "haptic child,"[50] experiencing art through

his senses and emotions a great deal more than through optical memory and reasoning. The impulsiveness of haptic children is usually the result of their total involvement in the experience of drawing. However, it leads them to create quickly rendered images which are often very messy. These pictures are not well received by traditionally trained teachers and, in the early 1940s, teachers were not generally concerned with the expressive vitality of an art work but rather with its naturalism.

Yusuf Amin was an exception to that rule. From the beginning, he gave special attention to al-Jazzar. However, òne must remember that this teacher was also a painter and a convinced theorist whose essential principle, recurring in most of his speeches, was that contemporary art thrives on contemporary thought. He encouraged his students to integrate art and ideas by parallelling what they learned in natural history, social studies and literature with the activity of art. Thus, it is in the context of a stimulating dialogue begun in school that al-Jazzar began to simultaneously channel his rational and intuitive expression into visual forms. From that point on, he learned to interweave deeply conflicting inclinations: his naturally impulsive treatment of colour and form, his extraordinary fantasy and his urge to express an extroverted outlook on the human condition and his own environment. The originality of his style and the force of his social statements are the result of this remarkable discipline.

As a painter, he assumed the roles of expressionist poet and visual analyst:

> Al-Jazzar is waging a combat between the angel and the beast, the unconscious and intelligence, traditions and myths. His non-representational approach has more realism than many realistic expresions.[51]

Aimé Azar's metaphor is supported by Subhi al-Sharuni's reference to the painter's early period (1946-1950):

> From the beginning, it was clear that al-Jazzar was approaching art intellectually. His pictures were loaded with literary and philosophical references. By trying to free himself from the tyranny of appearances he became very aware of nature's subtleties. His work shows that he accounted for every detail with lucidity and that he consciously avoided any external formal influence.[52]

His first series of drawings, exhibited in 1946 when al-Jazzar was only twenty-one years old, was based on the anthropological theme of man before civilization and his relationship with the wilderness. The ink drawings depict figures emerging out of swamps, others sitting like prehistoric earth goddesses beside gigantic sea shells, a woman lying like a prey atop an enormous tree branch, and other nightmarish images. The primitive themes may recall some of Gauguin's late Marchese Island works, but el-Jazzar's images represent a negation of Gauguin's luscious Pacific paradise. Instead, they depict a

sterile environment inhabited by people without joy or faith who exist in a post-innocent state objectified by sexual shame. If the style of these drawings seems to contain a premonition of the Neo-Expressionist trend which appeared in Europe and the U.S. in the 1980s, their content is closer to the empathic attitude expressed in the poetry of Salah Abd al-Sabur (*People of my Homeland*). Indeed, a few years later, al-Jazzar composed satirical poems such as "Abu Dayl" ("Men With Tails"), which he set to music and accompanied with the *ud*.

Al-Jazzar was born in Alexandria in 1925. Soon after, his family moved to the village of Burma in the centre of the Delta, and then settled in Cairo in the district of Sayyida Zaynab (Our Lady Zaynab). It was in this school of the streets, where mediaeval traditions had resisted all the winds of modern westernization, that the young painter learned the lessons of his people and their arts. This quarter surrounds the mosque of Zeinab, the daughter of Ali and one of the very few notable women of Islam. Because she is also considered one of the patrons of the city, her *mulids* or religious festivals have been celebrated since Fatimid times. At the southern edge of the district is a

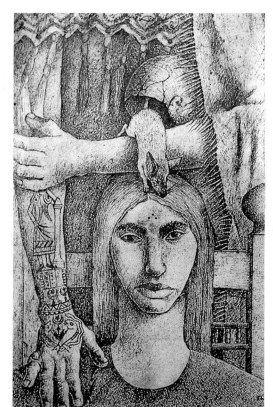

§ Abd al-Hadi al-Jazzar *Mechanics of Destiny* (ink), 1949, artist's collection (photo: author)

§ Abd al-Hadi al-Jazzar *The Young Sorceror* (ink), 1954, artist's collection
(photo: author)

slaughterhouse: one is never far from the sight or smell of animals brought in daily, but especially on the eve of the *Id al-Adha* (Great Bayram), commemorating the sacrifice of Abraham. The quarter also includes a train station, as a result of which a vast ethnic population pours into the area headed towards a variety of destinations: the banks of the Nile, Cairo University, the mediaeval southern Necropolis by the Mukattam Hills. Finally, the district is notorious for its underground trade in narcotics and its impenetrable back alleys. Here, every sort of popular magic is still being practised: fortune-telling, purification rituals, collective exorcisms. One can imagine, then, how the son of a conservative religious man and the heir to a previous generation of surrealist painters began to associate the intuitive aspect of art, the soul, with the essential element in the popular mystic arts: the hidden unknown.

§ Abd al-Hadi al-Jazzar *The High Dam* (oil), 1964
(photo: Sobhi al-Sharuni)

The second period of al-Jazzar's career (1948-1960) reflects this influence. With paintings such as § *Woman With Khulkhal* (1951) and § *Mechanics of Destiny* (1949), Jazzar's work became the focus of considerable attention triggered by the remarkable aesthetic qualities and originality of his imagery. The artistic experience of these twelve years is also interesting because throughout it unfolds al-Jazzar's increasing social consciousness, which he expressed by immersing his own poetical imagery in his people's collective memory. Individual social consciousness translated metamorphically into a collective subconscious imagery is, by definition, revolutionary.

The role of the artist envisioned by al-Jazzar functions within this supra-realist context and coalesces in the image of the sorcerer. It is an image which recurs explicitly in such paintings as § *The Young Sorcerer* (1954), *The Lesson of Spiritism* (1951), and is consistently present in most of his work through the presence of symbolism referring to magic.

As in the ancient Egyptian principle which asserts the unity of the Act and

§ Abd al-Hadi al-Jazzar
Waiting for the End (ink), 1964.
(photo: Sobhi al-Sharuni)

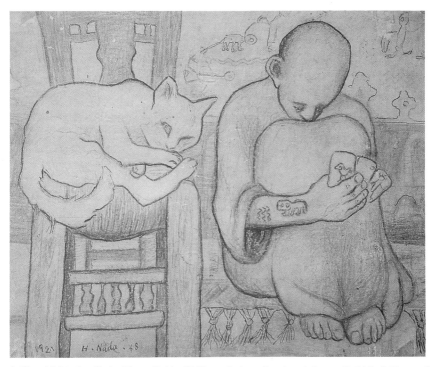

§ Hamid Nada *Cat's Sleep* (ink), 1948, artist's collection (photo: Sobhi al-Sharuni)

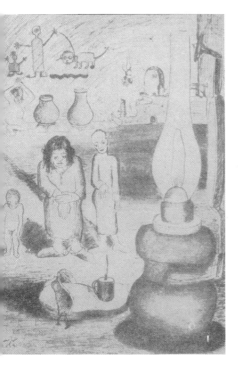

§ Hamid Nada *Lamp of Gloom* (oil), 1946
(photo: author)

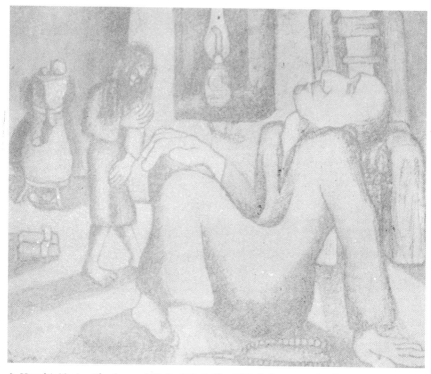

§ Hamid Nada *Shadow of Kob Kab* (oil), 1946 (photo: author)

the Voice, al-Jazzar perceived magic as the release of power through an effective form and by an act of will. The sorcerer is both maker and user of this key of power. He is the distant descendant of the ancient "Masters of the Voice": a legacy of the wisdom of the god Thoth, the magician. He is also the maker of revolutions: the contesting artist who invokes the spirit of change. Al-Jazzar's ideas about power evidently changed as the times changed. In § *Al Missakh* (1962), he saw power in the content of the Revolutionary charter in the hands of Egypt. The nation is symbolized once more by the *fellaha* and her ancient double, the Goddess of the Tree: Hathor, the Great Mother before whom all men of science and religion submit.

At equal distance between the priest and the scientist is the magician who sprang out of the first and contributed to the appearance of the second. The magician is nothing but a mediator whose position distinguishes itself from those of his colleagues by being permanently more uncomfortable. Furthermore, he is contestation itself. How true it is that he bears both the sacred and the necessity of exclusion from it.

Nothing is more striking in this respect than the panic still verifiable in our modern scientists. Having reached the forefront of atomic manipulation, they thought that they had become magicians. A senseless fear fell upon them. Wanting to escape what they thought to be the condition of the magician, they ended at the bottom line, with politics.[53]

This extract from Georges Hinayn's essay of 1950, *Considération sur la Magie d'une Egypte a l'Autre,* presages al-Jazzar's concerns during his third period in drawings like *The Scientist, Mechanical Men* and the *Aswan Dam* series. This period is also marked by the artist's return to visionary drawing after a short period in which he travelled to Europe and explored abstract painting. This period's obsession with technological hardware and its fantastic potential for destruction or salvation in Egypt's future could be attributed to his travels in the west, the controversy raised by the construction of the high dam, and the militarization of the country. The painting *Al-Sadd al-Ali* (§ *The High Dam,* 1964) presents a rather ambiguous commentary on political and economic developments in Egypt. By relating the Pharaonic gigantism of a Rameses to a project as ambitious as the dam, it pays tribute to the capability of the people; at the same time it makes a tacit comment on the post-revolutionary political situation.

In 1964, al-Jazzar returned to one of his recurring themes: the simultaneity of historical time and the collective memory, expressed in the bond attaching ancestors to their descendants. This originally Pharaonic sense of communal trust and love between the living and the dead, defying the loneliness of man in the face of his mortality, is expressed in the drawing § *Waiting for the End,* and in *Peace,* painted in 1965 a few months before al-Jazzar's own death.

Hamid Nada (1924-)
Laundry hanging in the blinding sun, closed shutters, a woman feeding chickens, pigeons, cocks, doors opening on interiors lit by the yellow glow of gas lamps, a straw chair, a sleeping cat, people dancing, arguing, loving— Hamid Nada's paintings are essentially autobiographical. These images originated in the atmosphere of the communal home in Khalifa where Nada was born. They evoke his neighbourhood and its traditions with folkloric details: a casual water pipe, a mischievous *djinn.* At the same time, his paintings are allegorical; they tell stories often inspired by the spirit of the story-teller Bahiyya al-Mahallawiya, a spiritual descendant of the fabulous Shahrazad. Even today, so many years later, the painter enjoys recalling parts of his nanny's fantasy tales, imprinted on his childhood visual memory:

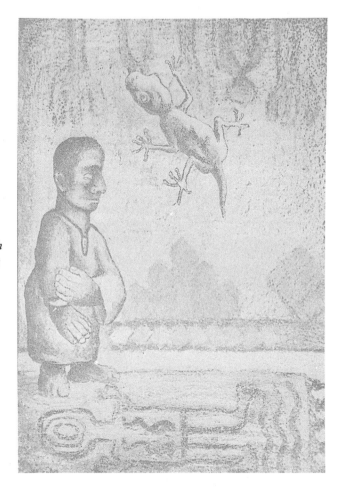

§ Hamid Nada
*Composition with
Lizard* (oil), 1947
(photo: author)

'...I am a weaver,' she began, 'from daybreak I spin and knot my coloured wools and at night I sell my day's work in the streets of the city. Last night, I noticed a colourful and merry company ahead of me. When I got nearer, I saw that it was a proud cock and five chickens. The cock sang and his company repeated his song after him. This happened again and again. I finally dared to ask: "Since when do chickens sing like cocks?" To that, the five chickens answered together, mockingly: "O really? And since when do pretty weavers sell their crafts past midnight?" Later, I saw them disappear into a deep hole in the ground, I followed, the hole led to a beautiful castle in the underworld. I saw them remove their feathers and their skins and...'[54]

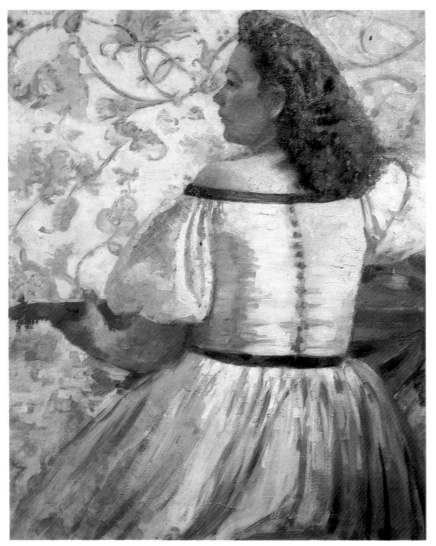

11 Ahmad Sabri *Lady with Oud* (oil), 1940, Museum of Modern Art, Cairo (photo: Sobhi al-Sharuni)

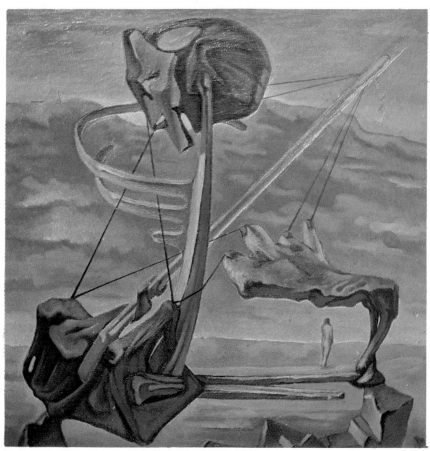

12 Ramsis Yunan *Nature Calling Void* (oil), 1945, Museum of Modern Art, Cairo (photo: author)

13 Ramsis Yunan *Composition* (oil), 1963 (photo: Sobhi al-Sharuni)

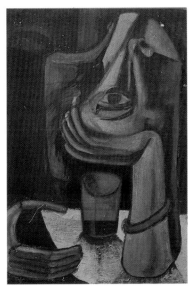

14 Fuad Kamil *Portrait of a Woman* (oil), late 1940s (photo: Sobhi al-Sharuni)

15 Fuad Kamil *Composition* (enamel on board), 1960, private collection (photo: Sobhi al-Sharuni)

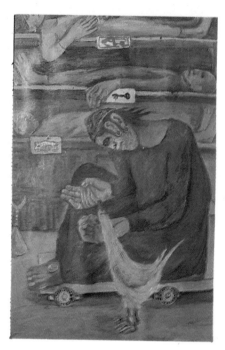

16 Abd al-Hadi al-Jazzar
The Green Cockerel (oil), 1952,
artist's collection (photo: author)

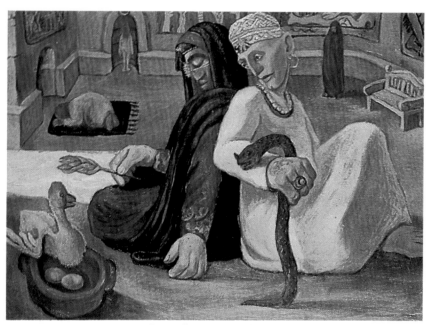

17 Abd al-Hadi al-Jazzar *The Ordinary Life* (oil), 1954, private collection (photo: author)

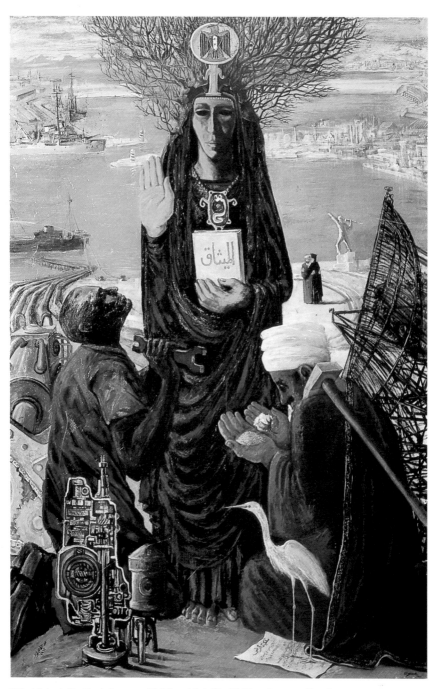

18§ Abd al-Hadi al-Jazzar *Al Missakh* (oil), 1962, private collection (photo: Tarek al-Razzaz)

19 Abd al-Hadi al-Jazzar *Folk Tale* (tempera), 1954,
Museum of Modern Art, Cairo
(photo: Sobhi al-Sharuni)

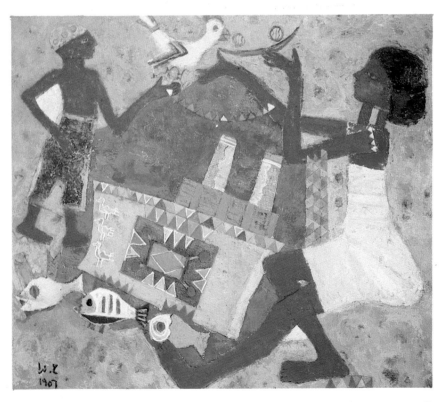

20§ Hamid Nada *Liberation of the Suez Canal* (oil), 1956 (photo: Sobhi al-Sharuni)

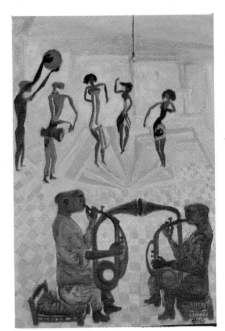

21 Hamid Nada *The Popular
Street Band* (oil), 1974
(photo: Sobhi al-Sharuni)

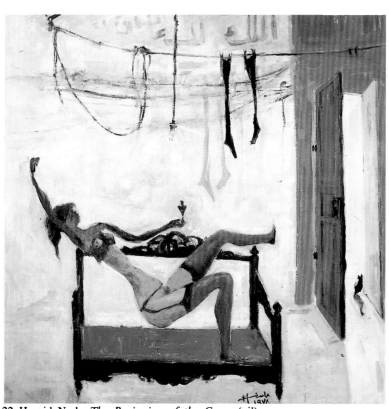

22 Hamid Nada *The Beginning of the Game* (oil),
1978, private collection (photo: Sobhi al-Sharuni)

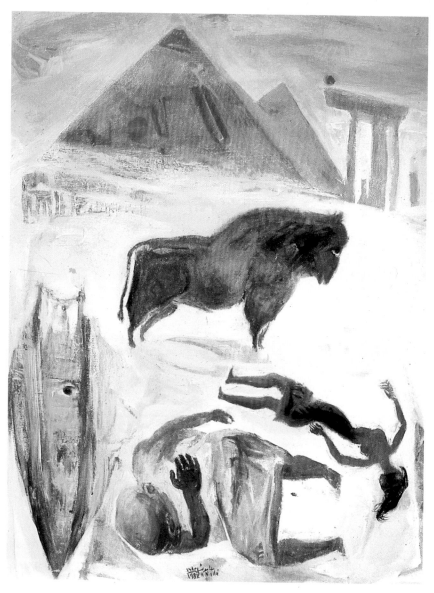

23 Hamid Nada *The City of Cairo* (oil), 1974 (photo: Sobhi al-Sharuni)

Egyptian folk tales are composed of fragments of *Arabian Nights* stories, African legends, Greek myths and Pharaonic mythology. Over time, the meaning and origin of these stories were forgotten as they were transformed by the fantasy of each narrator. The special quality of these narrative improvisations fascinates Hamid Nada. He enjoys discussing the nature of these tales in which nothing is what it appears to be, in which characeres keep switching their identities from mineral to animal to human in accordance with an unpredictable plot that occurs both on and under the earth. Nada's fascination with folk tales is not unlike that of Paul Klee who once said that he wanted his paintings to "sound like fairy tales,",to be a world "where things fall upward," and who claimed that his work owed more to Bach and Mozart than to any master of art. Although the styles of these two artists were very different, Nada's experimentation with formal distortions, rhythmic compositions and colours, beginning after 1954, suggests a growing affinity with Klee's acoustic and poetic aspirations. A retrospective view of the Egyptian painter's work will also show an evident spatial progression from down to up, as if the force of gravity pushing down on his forms was gradually reduced to vibrational wave-lengths suspending weightless shapes. This slow evolution from a visual to an acoustic perception of space parallels Nada's shift of attitude over the years, from objective to introspective.

During his first period, beginning in 1945, Nada's approach to art was marked by his association with the Egyptian Literary Society and their paper *al-Saqafa (Culture)*, a journal which systematically dealt with Arab culture and literature. The painter was also influenced by his introduction, during this period, to Yusuf Amin's Group of Contemporary Art by his school friend Abd al-Hadi al-Jazzar. Nada here describes the predominantly social-realist tendency of his earlier works:

> I lived in the quarter of Baghala surrounded by a religious atmosphere, since my father was a *shaykh* (man of religion). He used to tell me about the deranged and the *derwishes* and I, like many others, bowed to them and kissed their hands for the mercy of God and the spirits. Growing up made me develop a more inquisitive outlook. I became interested in psychology and read about psycho-analysis, and the works of Freud and Adler dealing with disguised pathological behaviour. I became aware of the tragic conflict between the inner and outer lives of the lower middle class and realized how empty and shallow was the life of those who sat for hours in cafes, as if they were carved out of stone. These bald heads, plump fingers, heavy feet in yellow and red slippers—they all looked contradictory and funny to me. Many of the aspects of the indigenous life made me smile and shake my head in empathy.[55]

In his early drawings, Nada's social-realist themes are conveyed with a sensitive metaphorical use of space. § *The Lamp of Gloom* (1946) refers to the limitations of visibility among the underprivileged, symbolized by an over-

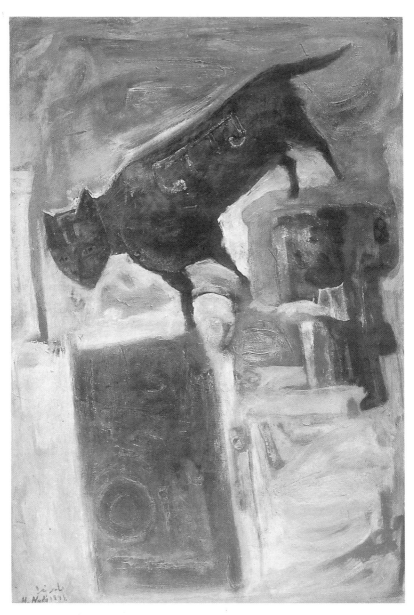

Hamid Nada *The Black Cat* (oil), 1967, artist's collection (photo: author)

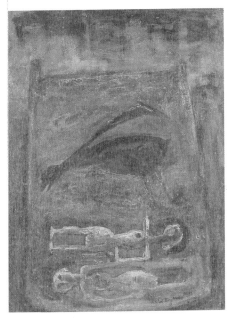

Hamid Nada *The Crow* (oil)
(photo: author)

sized lamp casting an inadequate and yet blinding light on the diminished human figures. In § *Shadow of Kob Kab* (1947), the sense of confinement is emphasized by the figure's shadow which fills the pictorial space as if it were a prison cell. In § *Composition with Lizard* (1947), Nada uses the folkloric reference and the environment in a theatrical manner that prefigures Tawfiq al-Hakim's folk surrealist play *The Tree Climber*. These works, among others like *The Birds* (1948) and *The Derwishes* (1947), belong to his "sculptural" period: Nada approaches his subject with the eye of a literate spectator who explores plastic space as a separation between static solid and rounded objects. From among all the artists of the Group of Contemporary Art—al-Jazzar, Yusuf Kamil, Ibrahim Masuda, Mahmud Khalil, al-Habashi and Ahmad Mahir Raif—Nada has the strongest spatial awareness of masses and forms. Eventually, following his graduation from the School of Fine Art, his talent as a colourist began to emerge.

In 1954, Nada was among nine Egyptian artists representing Egyptian painting in Paris. Simone Lacouture reviewed his work in *La Revue du Caire:*

Nada does not treat drawing as lines anymore, but as coloured matter: one could approach his drawings as paintings...His figures are encircled in a closed heavy universe symbolized by a concentric design. From daily life, he extracts symbols like the chair, the lamp or the cat which are destined to make palpable "that other thing" not experienced by the character but apprehended by the painter. The extraordi-

nary quality of the drawings allied with the research in composition give to his work a weight and an assurance which is surprising coming from an artist who is only twenty-eight.[56]

The attention to colour and the shift in his poetic inspiration mark Nada's second period. The change resulted in part from the exhilarating optimism and strong sense of liberation introduced by the Revolution. The political atmosphere had its impact on Nada and he expressed it by abandoning the tragic themes which dominated his earlier period. He now concerned himself with happier, more positive situations. Nada's work began to show an increasing affinity with the folk expressionism of Raghib Ayyad, and a serious interest in Egypt's Pharaonic and Nubian artistic heritage. As well, he became involved in international trends in contemporary art. From this period onwards, Nada's iconography is simplified to a selection of strongly outlined shapes: the cat, the lamp, the human figure, the chair, the horse, the cock, etc. In each painting, Nada assembles these personal symbols in a graphic constellation with repetition, distortion, balance and chromatic harmonies all carefully calculated. It is as if each painting is a personal subconscious chart. § *Liberation of the Suez Canal* (1956) depicts a man and a woman involved in a dance with the fish of prosperity (their escort from the sea) and the white hen of hope (their escort from the sky). Even the boat at the centre of the painting flies like a magic carpet. Forms have begun to take off like kites; the magic of the fairy tale and Bahiyya's freedom of fantasy now become an integral part of Nada's allegories. His paintings begin to look like a contemporary integration of the Arab miniature and the Pharaonic mural. Only the written script is lacking. The result is cryptographic, but Nada defends this aspect of his work through a comparison with Mahmud Mukhtar: pointing out that while Mukhtar was mainly attracted by the objectivity of Pharaonic hieroglyphs, he, Nada, is more fascinated by their mystery. He adds that this, perhaps, is the essential difference between ancient and contemporary Egyptian art.

Eclecticism is, in Nada's case, deliberate. To understand it, one must consider the importance of surrealism in his art, but there is more to it than that. Nada was consistently interested in the condition of the illiterate man—talking, listening, gesturing—and this led him towards the path of primitive abstraction. It Africanized him. As a result, Nada became more introspective and his social statements found expression in increasingly subtle allegorical associations. In his earlier works, Nada expressed his ideas about the relationship of perception and action in such works as § *The Lamp of Gloom*. In the 1960s, he focussed on a new realization based on the association of art and cultural autonomy as experienced through the struggle for development in Third World countries. From a starting-point rooted in pre-literate societies and a regional perspective, Nada reversed the experience of Picasso and the European Cubists who westernized African art by formalizing it. In the conclusion to his essay on Hamid Nada, Izz al-Din Najib emphasizes Nada's unique position:

Nevertheless, a truth that no one can deny is that Hamid Nada, with all his diverse and fertile experimentation, is a single example of the potential for autonomy of the artist who belongs to a country such as ours rather than to the western world, in spite of the fact that, among all the native painters he is the one who is most aware and better informed about international art trends as they appear to, and as they impress, the majority of Egyptian and Arab artists.[57]

In his later period, Hamid Nada, by systematically abolishing the third dimension, distorts his figures according to the expressive needs of each element as they contrast on the flat surface of the canvas. He transposes his plastic language from the visual spatial perception, associated with the literate civilized man, to an oral abstracted vision which is closer to the preliterate, pretechnological Third World man. From the primitive and African arts, Nada learned to increase the acoustic range of his pictorial space through the use of rhythmical repetition and symmetry. *The Argument* and § *Popular Street Band* (1974) can be seen in these terms. They also transpose the problem of alienation and perceptual communication from the visual to the acous-

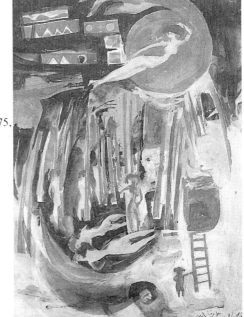

Hamid Nada *The Dream* (oil), 1975, private collection (photo: author)

tic plane, as musical instruments and voices replace the lamp and shadows of his earlier works. Now more than ever, looking at Nada's canvasses one feels that one is hearing with one's eyes. They actually do "sound like a fairy tale." His characters are liberated from their previous social identity and, as in Bahiyya's tales, they are now free mythical and universal entities.

But Hamid Nada was not an isolated case. The fundamental work accomplished by three generations of artists finally brought modern Egyptian art to the attention of the world in the 1950s. Five decades of experimentation bloomed and a new plastic language evolving from native roots was born. The critic John Berger who visited the Venice Biennale in 1958 was among those who enthusiastically responded to the new Egyptian school:

> And then there was the pavillion of the United Arab Republic (Egypt). Only occasionally do history and art correspond with each other as directly as they do here; but it remains a fact that this pavillion was the most affirmative and vital of all the 1958 Biennale. I do not, of course, mean that geniuses have appeared overnight in Cairo. What makes these works outstanding is that they affirm, they are not defensive treaties. Man comes before things. Their language is largely traditional. It is sun dried colours; its expressive use of decorative silhouettes, and its easy and unself-conscious simplifications deriving from traditional Egyptian art and design. Yet it is the art of the West that appears by contrast to be not only academic, but also in the context of the emerging twentieth-century world, finished, exhausted, outlived.[58]

FOUR
Design for a New Egypt

In the work and personality of the Egyptian architect Hasan Fathi we find the supreme embodiment of the distinctive antiformalist and humanitarian qualities which so impressed John Berger at the 1958 Biennale. At the time of the Biennale, Fathi was not yet a world renowned architect. In his country he was controversial and rather misunderstood. But this situation began to change with the publication in Cairo in 1968 of his book *A Tale of Two Cities*. The book was later re-entitled *Architecture for the Poor* and reprinted in the U.S. in 1972 and later in France. (It has still not been translated into Arabic.) It is now a classic, read and discussed in architectural schools and counter-cultural circles around the world. In the Middle East, Fathi is considered a pioneer in Islamic architecture. His followers include his friend, Ramsis Wissa Wasif, and his student, Abd al-Wahhab al-Wakil. Fathi's achievements in mud brick architecture, deriving from the building tradition of rural Egypt, place him in an odd position among world architects; but his humanitarian approach to architecture and his self-assumed responsibility as an individual artist qualify him as an outstanding theorist and teacher. In a recent assessment of Fathi's lifetime work, the journalist Abdullah Schleifer wrote:

> What Hasan Fathi was, and remains, is a man committed first to the rehabilitation of the Egyptian countryside and then by extension, in the years of work, travel and thought that have followed, to the rural rehabilitation of the entire Third World—the 900 million poor who live outside the cash economy and are without means to purchase the most minimal-standard housing.[59]

In order to grasp Hasan Fathi's achievement and the full significance and potential of his work, it is necessary to see him in the context of the Egyptian architectural tradition. Then we will find that, if Mahmud Mukhtar stands at the beginning of modern Egyptian art, Hasan Fathi opens that art to the future and to a reality beyond Egypt.

Architecture in Modern Egypt
The first great master builder in Egypt's history was Imhotep, the man responsible for the Sakkara complex (2600 B.C.). To him are attributed the first experiments in monumental stone architecture and the discovery of that material's essential properties. His Pyramid is the foundation of the supreme architectural achievements of ancient Egypt.

Baron Empain Palace, Heliopolis: oriental ornaments on the southwest corner, by Alexandre Marcel (photo: author)

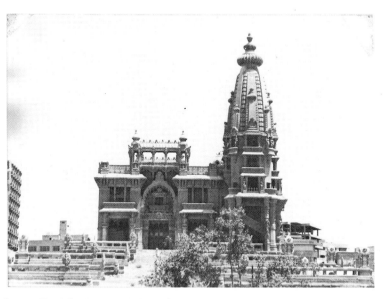

Baron Empain Palace and landscaped terraces, Heliopolis, by Alexandre Marcel (photo: author)

But Egyptians never lived in stone houses. From the predynastic ages, their settlements were built out of the most common building material in the Nile Valley: earth. Mud bricks or adobes are a mixture of silt, straw and sand left to dry in the sun. By adding a stone foundation to the mud brick house and, with palm trees, some additional reinforcement, or by roofing it with self-supported bricks, arches and domes, the ancient craftsmen achieved airy, solid and diverse structures that were as suitable to the hot dry climate as they were to the economic and environmental conditions of the agricultural folk society. Mud house builders were craftsmen able to combine the balancing skills of potters with the structural knowledge of masons. They translated old inherited techniques of construction while relying on a traditional sense of beauty and design. They qualify as creative artists because the form, function and originality of each house depended on the simultaneous act of conception and execution.

Traditions languished. Houses lost character and villages deteriorated. The knowledge of how to build domes and arches without wood frame supports was forgotten. Yet, the mud bricks remained because the *fellahin* could not afford or find anything else to build with. Their houses, constructed of the ancient sacred material, became symbols of poverty and ignorance. Hasan Fathi explains what followed:

> The tradition is lost and we have been cut off from our past ever since Muhammad Ali cut the throat of the last Mameluke. This gap in the continuity of the Egyptian tradition had been felt by many people, and all sorts of remedies have been proposed.

Hasan Fathi adds ironically that the choice of whether to adopt Pharaonic or Islamic architectural styles was the source of many animated debates:

> Indeed, there has been one statesmanlike attempt to reconcile these two factions, when Uthman Muharram Basha, the Minister of Public Works, suggested that Egypt be divided into two, rather as Solomon suggested dividing the baby, and that Upper Egypt be delivered to the Copts, where a traditional Pharaonic style could be developed, while Lower Egypt should go to the Moslems, who would make its architecture truly Arab!*
>
> The story goes to show two things. One is the encouraging fact that people do recognize and wish to remedy the cultural confusion in our architecture. The other—not so encouraging—is that this confusion is seen as a problem of style, and style is looked upon as some sort of surface finish that can be applied to any building and even scraped off or changed if necessary.[60]

*In fact, this dispute was resolved by a decree which still exists today.

Decisions about stylistic choice were further complicated by the clash between modern and traditional ways of life. Colonial architecture, implanted in the cities, the countryside and even the desert offered an attractive vision of the future by shaking traditional notions of a habitable environment. The writer Hussayn Haykal remembers:

> ...that day in 1909 when my father took me as far as Heliopolis, it was barely coming out of the ground. There were only a few mansions around the Heliopolis Palace. I heard my father express his astonishment about the choice of that desert location, where the Belgian company promoting the project had chosen to build the new suburb. But then, Egyptians believed in the genius of foreigners, in whom they saw angels or devils. Therefore, they were cautious in making a hasty judgement about their behaviour. These foreigners, they thought, know more than we do. I shared on this day the astonishment of my father when he saw, coming out of El Abbassya, the white train connecting Cairo to Heliopolis, rolling through an empty spread of lifeless desert sand, as far as the eye could see.[61]

The construction of the suburb of Heliopolis was the ambitious scheme of the wealthy entrepreneur, Baron Empain, who dreamed of reviving the ancient city of Heliopolis in the form of a modern, and highly profitable development. Years later, in 1945, Hasan Fathi initiated the construction of an equally ambitious project, the village of New Gurna. A comparison between these two projects is enlightening. Empain's commercial development was a success story while Fathi's visionary NewGurna proved a failure. The reasons behind this unfortunate situation reflect the complexity of the problems that have resulted in the distressing nature and lack of character of modern Egyptian architecture, and suggest both cautionary strictures and new directions for the future.

Heliopolis

By 1906, Egypt was like the Kuwait of the 1950s. The Suez Canal, the political stability imposed by the British iron fist, the boom in the price of "white gold" (cotton), the abundance of cheap labour and the concentration of wealth in the hands of the ruling class all combined, unfortunately, to make it a paradise for capitalist entrepreneurs. Speculation in real estate and the growth of the urban population attracted tycoons like the Baron Empain:

> I want to build a city here. It will be named Heliopolis, the city of the sun. First of all, I want to build a palace. I want it to be magnificent and I also wish the architecture to be in conformity with the traditions of this country. I wanted a specialist in Arab art, I could not find one. You love mosques, you are an architect, why don't you submit to me a preliminary project?[62]

The Baron was addressing himself to Marcel Jasper, the Belgian architect

who designed the Abbas Boulevard and the Heliopolis Palace, the latter the largest hotel in the world for many years. Jasper was paired with Alexandre Marcel, a businessman and specialist in exotic architecture. Empain had approached Marcel after the latter's return from India where he had just completed a Renaissance palace for the Maharaja of Kapourtala; in Belgium, he had constructed a Chinese pavillion and a Japanese tower for King Leopold II. The Baron demanded that both men work towards a stylistic unity, thus giving a visual coherence like that of Cairo's Garden City area. What escaped him, however, was the irony of a development in which western style buildings, serving a variety of purposes and responding to the economic means of a colonial hierarchy, were supposed to look Arab. In his grandiose vision of reviving the ancient city of the sun, Empain even commissioned the Belgian architect Jean Capart to search for its original foundations, a sensitive consideration that is, indeed, to the developer's credit. The question remains, however, why interpret local traditions as Arab and not Pharaonic? Perhaps the answer is to be found in the comment of the French Ambassador who observed that "the impression one gets on arriving in Heliopolis's main avenue is the same one experienced by visitors to some section of the Universal Exhibition of 1900."[63]

This exhibition in Paris was a landmark in the world history of communication arts. The first such exposition to benefit from the new invention of the electric light and other electrical devices, it surpassed any previous record of attendance by attracting 34 million visitors. It also featured, for the first time, many pavillions from non-western civilizations. Islamic arts were especially favoured, being in fashion at the time. G. Marya, organizer of the first great exhibition of Islamic art in Paris in 1893, observed:

This art, which was scorned until now, is starting to provoke in Europe a movement of opinion similar to the one Far Eastern arts have benefitted from for the last twenty-five years.[64]

The Neo-Moorish style adopted in Heliopolis therefore originates in a taste for Islamic decorative arts and grandiose scenographic effects, introduced into Egypt by European colonialists and orientalists. It does not represent any extension or reveal any understanding of traditional architecture in Egypt. Domes and arches, for instance, are added for purely ornamental effect and serve no other function. Private gardens, arcades and loggias surround the buildings, facing the exterior as in Italy or France, whereas in traditional Islamic architecture they would be enclosed within the buildings. This satellite city of Cairo was designed as a very attractive model of the multinational colonial way of life at the turn of the century. As a prototype, it included all the values and achievements of that society, packaged in a form designed to appeal to Egyptians and foreigners alike.

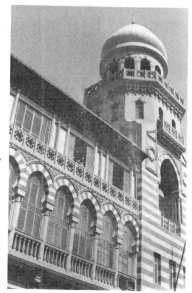

Facade with ornamental arches and tower, Heliopolis (photo: author)

Heliopolis Palace: reception area, by Marcel Jasper (photo: author)

Hasan Fathi (1902 -

Hasan Fathi belonged to that generation of artist-thinkers like Habib Jurji and Hamid Said who felt that genuine Egyptian art and the revival of traditional crafts had to be tackled simultaneously, since the first represented a search for the Egyptian personality and environment while the second represented their product. In their perception, Egypt was an agricultural society and the future of Egypt lay in the hands of its *fellahin*. Like many other intellectuals of the Neo-Pharaonist generation, they were convinced that, by understanding and adapting an ethnic heritage, a modern national art would emerge. These artists shared a purist attitude. They believed, at the time, that the merging of ancient and modern art would succeed only if no external interference in the adoption of materials, techniques or cultural assessments were to influence their experiments.

Hasan Fathi was a young nationalist who graduated from the architectural school in the 1930s, but felt no interest in working for the metropolitan western architectural firms; he was driven very early in life by a compelling desire to design for his own people. He was distressed by the condition of houses in Egypt, unsuitable for the environment, lacking stylistic coherence and built with expensive imported materials which even the rich could scarcely afford. Fathi finally concluded:

And here, in every hovel and tumbledown in Egypt, was the answer to my problem. Here for centuries the peasant had been wisely and quietly exploiting the obvious building material while we, with our modern school-learnt ideas, never dreamed of using such a ludicrous substance as mud for a serious creation such as a house. But why not?[65]
And then it occurred to me that if I had nothing but mud bricks and nothing else, I was no worse off than my forefathers. Egypt has not always imported steel from Belgium and timber from Rumania, yet Egypt has always built houses. How did they build them? Walls, yes. I could build walls too, but I had nothing to roof them with. Couldn't mudbricks be used to cover my houses on top? What about some sort of vaults?[66]

After several unsuccessful attempts at building vaults without supporting wood frames, Fathi was advised by his brother to go to Aswan where some traditional villages still existed:

On entering the first village, Gharb Aswan, I knew that I had found what I had come for. It was a new world for me, a whole village of spacious, lovely, clean and harmonious houses each more beautiful than the next. There was nothing else like it in Egypt; a village from some dream country, perhaps from a Hoggar hidden in the heart of the Great Sahara, whose architecture had been preserved for centuries uncontaminated by foreign influences, from Atlantis it could have been. Not a trace of the miserly huddle of the usual Egyptian village, but house after house, tall, easy,

roofed cleanly with a brick vault, each house decorated individually and exquisitely around the doorway with calustra-work, mouldings and tracery in mud.
I realized that I was looking at the living survivor of traditional Egyptian architecture, at a way of building that was a natural growth in the landscape, as much a part of it as the dom-palm tree of the district. It was like a vision of architecture before the Fall; before money, industry, greed and snobbery had severed architecture from its true roots in nature. I was delighted, the painters who had come were in ecstasies. At every corner they sat down, unwrapped canvasses, put up easels, seized palettes and brush and set in. They started, exclaimed, pointed; it was a gift in a million for an artist.[67]

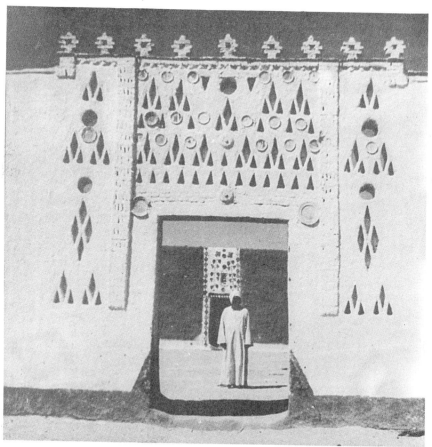

Nubian decorated portal with inlaid china plates

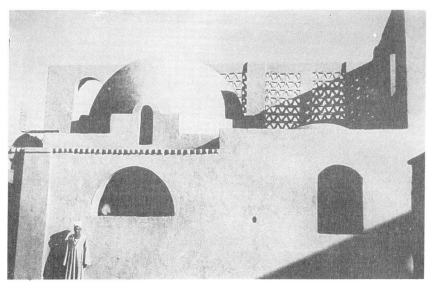

Mudbrick house in New Gurna, by Hasan Fathi

In 1945, Fathi began the construction of New Gurna. Gurna was a village traditionally inhabited by tomb robbers, nestled in the middle of Egypt's most crowded archaeological site, the Valley of the Kings. The Gurnis literally lived on the remains of their ancestors for centuries. Finally, a project aimed at the relocation of 7,000 villagers was passed and the task of building the new village was assigned to Hasan Fathi.

For Fathi, this was his chance to fulfill a dream. For years, he had been developing the idea of building the ideal village which could then serve as a model for the rural renovations which were so much needed throughout the country. His project for Gurna was the fruit of several years of thinking about how to apply theoretically sound methods of "aided self-help" by designing structures adapted to a developmental work process involving grass-roots education and participation. In New Gurna, style was the result of experimentation. Fathi relied on visual modulations achieved through scale balance, rhythmical repetition of domes and arches and by an inventive ornamental use of bricks. He explored the simplicity of forms dictated by their function and the flatness of surfaces imposed by the nature of the structural material. The overall effect is sober and aesthetically very contemporary. The purity of lines reduced to an essential geometry is well-suited to the simple planes of the landscape and the surrounding Pharaonic architectural monuments. The closest of these is the temple of Dayr al-Bahari (Hatshepsut) and in fact one

cannot help noticing an affinity between the temple and the village. Besides the magical effect of seeming both very ancient and very new, they are both examples of environmental architecture that unfortunately lack the landscaped vegetation with which they must be seen and which was an integral part of the original design.

Gurna is a masterpiece of planning. Mosque, schools, market-place, public bath and outdoor theatre are beautifully functional and well-integrated with the peasant houses. Fathi worked with sensitivity and dedication, attempting to include everything he could possibly learn about the villagers' traditional ways of living, working and thinking.

New Gurna is one of the major achievements of the Egyptian artistic awakening initiated by Mahmud Mukhtar. It is worthwhile, at the conclusion of this first volume of our study of modern Egyptian art, to compare the essential features and historical significance of the works of Mukhtar and Fathi. Both men were dedicated researchers, looking into the Egyptian tradition for a new language of forms. Each represents Egypt in terms of his own historical period. Mukhtar stands for an Egypt that, in an elite European context, evoked the glories of a great world civilization. Inspired by the discoveries of the great age of archaeology as it liberated the past from beneath the desert

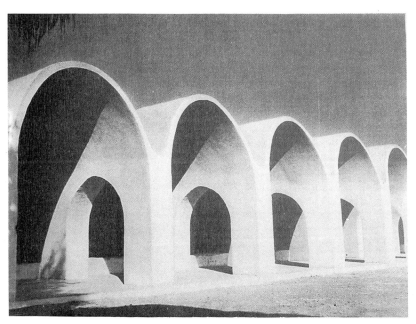

Market arcade in New Gurna, by Hasan Fathi

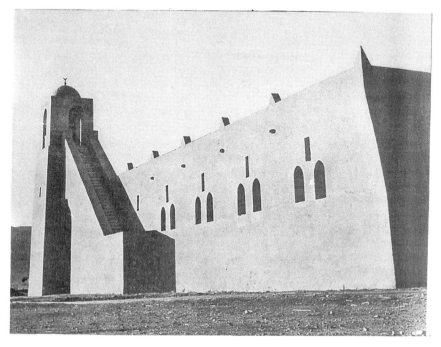

Mosque and minaret in New Gurna, by Hasan Fathi

sands, Mukhtar drew his visual language and sense of scale from the Pharaonic state and its mortuary art. By contrast, Fathi represents an Egypt in the process of revolutionary developments involving the masses of the people. One could say that, if Mukhtar looked into the soul of the nation, seeking the visual form for the idea of nationalism, Hasan Fathi looked to that nation's body, seeking to actively participate in the design of the nation itself. Mukhtar's art emerges from the desert, calling on the past splendours of the national tradition; Fathi's architecture emerges from the black soil, returning it to the life of the people in a perpetual germinating process, the continuing environmental presence of the tradition. In a sense, Mukhtar represents a closure: Neo-Pharaonism, like Neo-Classicism, recapitulated the past. After Mukhtar, there was no major Neo-Pharaonist artist and the movement left little continuing trace after the 1930s. Fathi, on the other hand, opens the way to the future and to a reality beyond Egypt. Drawing his inspiration from the Third World nature of Egypt, separate from its connection to western civilization, he moves forward into the Third World as a whole and the realities of the post-colonial period. His contribution is likely to take a slower path to success but, once fully recognized, to be longer-lasting.

Within his plan for New Gurna, Fathi scientifically calculated the feasibility and prospects for the community's self-sufficiency. He hoped to create a prototype, a self-propelled time capsule that would continuously preserve and update itself. He failed, however, in his understanding of people and their traditions. Both can change, but not always simultaneously. Unlike Heliopolis, Gurna was not a success story because the people it was designed for did not exist. Like any prototype, even a new village must be understood so that it can be maintained and multiplied. For that, a new consciousness had to exist. Bureaucrats and tomb robbers are not revolutionaries.

Yet these officials and those who head their offices are ordinary men, part of the people like all of us. Individually, they are kindly, sensitive and intelligent and, one hopes, anxious to rebuild their country. Can't they see that revolutionary ambitions need revolutionary measures? Or are we all at the mercy of a system of official procedure that everybody hates, that is universally recognized for a harmful choking growth of weeds, and that no one is prepared to uproot?[68]

Fathi's outraged comment is a key point in the *prise de conscience* of the Egyptian artist faced with the hard reality of the bureaucratic system. Finding creative solutions as individual artists is one thing, applying them is another.

From the beginning of the modern period, with Mahmud Mukhtar, the elements inhibiting the development of a national art were seen as pressures coming from outside the country, pressures which could be removed by reforms and political independence. Beginning in the mid-1950s, the focus began to shift to the enemy within: the burden of bureaucracy and the inefficiency of obsolete and defeatist traditional views.

I hope, in another volume, to attempt to examine the impact of these two elements on the arts.

Notes

Abbreviations used in the notes

Abou Ghazi & Boctor, *Mahmoud Said* = Badr El Din Abou Ghazi & Gabriel Boctor, *Mahmoud Said,* le Caire: Editions Aladin, 1952

Abou Ghazi & Boctor, *Moukhtar* = Badr El Din Abou Ghazi & Gabriel Boctor, *Moukhtar ou le réveil de l'Egypte,* le Caire: Urward et Fils, 1949

Atiya = Naim Atiya, *Al-'Ayn al-Ashiqqa,* Cairo: Dar al-Nashr, 1976

Awad = Luwis Awad, ed., *Dirasat fi al-Fann,* Cairo, 1966

Azar = Aimé Azar, *La peinture moderne en Egypte,* le Caire: Editions Nouvelles, 1961

Carrott = Richard G. Carrott, *The Egyptian Revival: Its Sources and Meanings,* California: University of California Press, 1974

Cavadia = Maria Cavadia, "Présence de l'art en Egypte: un signe d'éveil" (interviews with various artists), *Loisirs,* no.21, Spring 1950 (unpaginated)

Fathi = Hassan Fathi, *Gourna: A Tale of Two Villages,* Cairo: Dar al-Katib al-Arabi, 1968

Finbert = Elian J. Finbert, "Mohammed Naghi", *L'Art Vivant,* January 1924 (unpaginated)

Hoog = Michel Hoog, "Autour de 1900", *Catalogue de l'expositon Occident-Orient, l'art moderne et l'art islamique,* Strasbourg

Ilbert = Robert Ilbert, *Heliopolis: genèse d'une ville,* Paris: Centre nationale de la Recherche scientifique, 1981

Muhammad Abduh = Shaykh Muhammad Abduh, "Fatwah: al-Suwar w'al-Tamasil wa Fawa'idha wa Hukmaha", *Al-Maktaba al-Thaqafiyya,* no.98, December 1963

Naji *Retrospective* = *Mohammed Naghi Retrospective Exhibition Catalogue,* Prague: Higher Council of Fine Arts, 1958

Rasim = Ahmad Rasim, "Mahmoud Said", *La Femme Nouvelle,* December 1949

Vatikiotis = P.J. Vatikiotis, *History of Egypt: From Muhammed Ali to Sadat,* London: Weidenfeld & Nicolson, 1980

Notes

1 Azar, pp.16 and 19
2 Sarwat al-Bahr, *Exhibition Catalogue 1982,* Alexandria: Goethe Institute, 1982
3 Vatikiotis, p.9
4 quoted in Vatikiotis, p.35
5 Vatikiotis, pp.9-10
6 Ibid. p.213
7 Muhammad Abduh, p.13
8 Ibid. p.13
9 Carrott, p.82
10 Ibid. p.54
11 Ibid. p.4
12 Husayn Haykal, "al-Fann al-Misri", *al-Siyasa al-Usbuiyya,* April 1927, p.10
13 Husayn Haykal, *al-Siyasa al-Usbuiyya,* December 1927, p.23
14 quoted in Abou Ghazi & Boctor, *Moukhtar,* p.7
15 Abou Ghazi & Boctor, *Moukhtar,* p.39

85

16 quoted in Abou Ghazi & Boctor, *Moukhtar*, p.14
17 Abou Ghazi & Boctor, *Moukhtar*, p.46
18 Ibid. p.62
19 Badr al-Din Abu Ghazi, *al-Fann fi al-'Alamiyya*, Cairo: Dar al Maarif, 1973, p.157
20 "Mayy" *(nom de plume)*, "Nazra fi Fann Mukhtar", *al-Siyasa al-Usbuiyya*, November 12, 1926, p.6
21 Kamal al-Mallakh & Rushdi Iskandar, *Khamsun Sana min al-Fann*, Cairo, 1962, p.17
22 Badr al-Din Abu Ghazi, "Nahdit Misr wa 'Asr Mukhtar", *Al-Majalla*, no.66, July 1962, p.68
23 Ex-Queen Farida, Personal Interview with Author, October 22nd, 1983
24 Abou Ghazi & Boctor, *Mahmoud Said*, p.2
25 Ibid. p.15
26 John Berger, *Art and Revolution*, London: Writers and Readers Publishing Co., 1969, pp.50-51
27 Rasim, pp.28-30
28 quoted in Rasim, pp.28-30
29 Azar, p.34
30 Atiya, p.9
31 Finbert
32 Azar, p.22
33 Naji *Retrospective*, p.11
34 Ibid.
35 Finbert
36 Naji *Retrospective*, p.10
37 Awad, p.7
38 Azar, p.49
39 quoted in Azar, p.49
40 Catalogue of Exhibition "Art and Freedom", Cairo, 1940
41 Awad, pp.276-280
42 Hoog, p.32
43 quoted in Hoog, p.21

44 quoted in Atiya, p.65
45 Atiya, p.72
46 Azar, p.78
47 Cavadia
48 Ibid.
49 Edmond Muller, article on Rifa'i and Jazzar in *Loisirs*, 1953 (Numéro spécial sur l'année égyptienne des arts et des lettres)
50 Victor Lowenfeld & Lambert Brittain, *Creative and Mental Growth*, 6th ed., New York: Macmillan, 1975, p.275
51 Azar, p.116
52 Sobhi al-Sharuni, *Abd al-Hadi al-Jazzar*, Cairo: Hayat al-Kitab, 1966, p.10
53 Georges Henein, "Considérations sur la magie d'une Egypte à l'autre", *La Femme Nouvelle*, December 1950, pp.69-70
54 Hamid Nada, "Recollections of Baheyya's Tale", Personal Interview with Author, April 1984
55 quoted in Atiya, p.124
56 Simone Lacouture, "La jeune peinture égyptienne à Paris", *La Revue du Caire*, November 1954
57 Izz al-Din Najib, *Ibdaa*, January 1984, p.128
58 John Berger, *Towards Reality: Essays in Seeing*, New York: Alfred Knopf, 1962, p.39
59 Abdullah Schleifer, "Hassan Fathi: A Voyage to New Mexico", *Arts and the Islamic World*, Winter 1982/83, p.31
60 Fathi, p.31
61 quoted in Ilbert, p.129
62 Ilbert, p.81
63 Ibid. p.92
64 quoted in Hoog
65 Fathi, p.11
66 Ibid. p.12
67 Ibid. pp.13-14
68 Ibid. p.239

Index

87

Vinci, Leonardo da, 33

al-Wakil, abd al-Wahhab, 73
Wasif, Ramsis Wissa, 43, 73
White, Stanford, 7

Yunan, Ramsis, 21, 30, 32, 33

Zaghlul, Ahmad, 11
Zaghlul, Saad, 11, 14
Zulfikar, Farida, 19